The Art of
Lee Miller

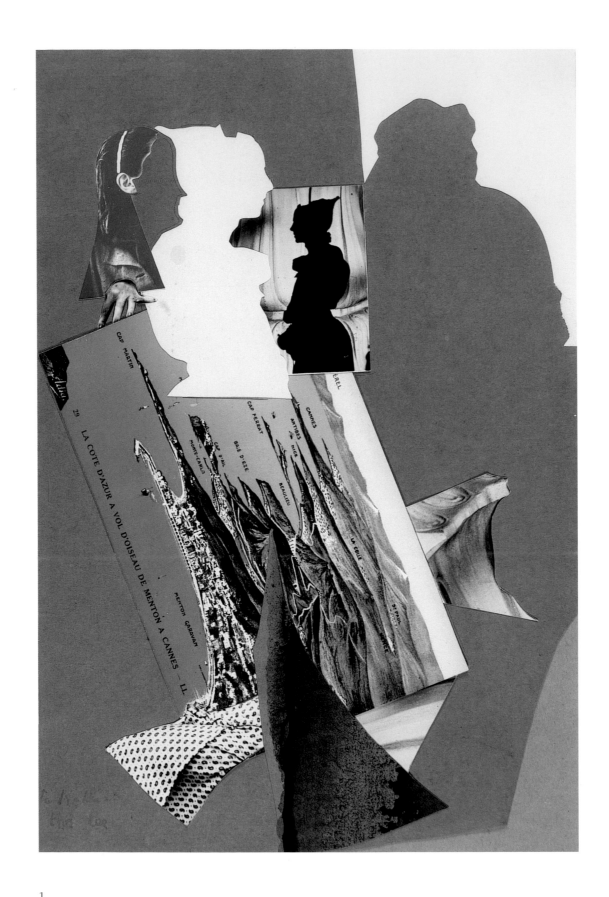

1

Untitled

collage, 1937

The Art of Lee Miller

Mark Haworth-Booth

V&A Publications

Olympus is delighted to sponsor *The Art of Lee Miller* at the V&A. From the first Olympus Trip camera, used by David Bailey, to the very latest Olympus E-System Digital SLR, our philosophy has remained the same – the point of a great camera is to help people take great photographs. Lee Miller was a unique photographer – unconventional, challenging. We can provide the tools – it's up to you what you achieve with them. We hope this exhibition and book will inspire you!

Graeme Chapman
Managing Director, Olympus UK Ltd

OLYMPUS

First published by V&A Publications, 2007
V&A Publications
Victoria and Albert Museum
South Kensington
London SW7 2RL

Hardback edition
ISBN-13 9781851775040

10 9 8 7 6 5 4 3 2
2011 2010 2009 2008 2007

A catalogue record for this book is available from the British Library.

Designed by Geoffrey Winston

Front jacket illustration: *Self-portrait* (Pl. 20)
Back jacket illustration: *Portrait of Space* (Pl. 122)

Origination by Technolito, Caprino Bergamasco
Printed in Singapore by C.S. Graphics

V&A Publications
Victoria and Albert Museum
South Kensington
London SW7 2RL
www.vam.ac.uk

Contents

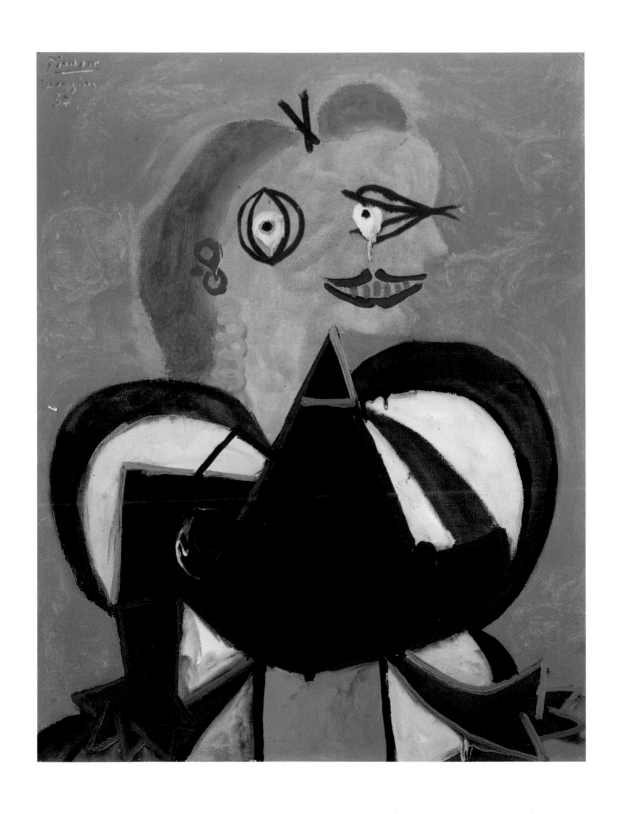

2

Pablo Picasso *Portrait of Lee Miller à L'Arlésienne*

1937

Introduction

LEE MILLER is making a surrealist jig-saw puzzle – which, you will admit, is a puzzle.

Creative Art, New York, May 1933

This book brings together for the first time all the arts which comprise the *œuvre* of Lee Miller (1907–77). The book and the accompanying exhibition, organized by the Victoria and Albert Museum, celebrate the centenary of her birth and mark the thirtieth year since her death. We hope that this centenary salute will reveal in full the talents of a quintessential twentieth-century artist. In retrospect, Lee Miller was a woman the twentieth century needed to create – independent, liberated, creative, courageous and multi-talented – but she was her own remarkable invention. Her extraordinary career as an artist defies stereotypes. Despite being increasingly admired and studied in recent decades, she remains 'a surrealist puzzle'.

Lee Miller was born in Poughkeepsie, New York, in 1907 and died in Sussex, England, in 1977. She was photographed constantly as she grew up by her father, Theodore Miller, a serious amateur. She modelled for New York's outstanding portrait and fashion photographers in the 1920s. When she moved to Paris in 1929, she became the muse of the Surrealist movement, inspiring iconic imagery in photography and film, paintings and sculpture, as well as reigning over the fashion pages of Paris, London and New York. In addition to practising the art of the model at the highest level, Lee Miller became one of the most interesting Surrealist photographers in Paris. All her most outstanding works have been brought together here for the first time. Some have never been illustrated before. She took part in important, pioneering exhibitions at the Julien Levy Gallery in New York and opened a stylish and successful portrait studio in the city in 1932. In 1934 she married an Egyptian, Aziz Eloui Bey, and lived with him in Cairo. She made some of the most haunting photographs of Egypt in modern times before returning to her Surrealist friends in the late 1930s.

In 1937 Lee Miller met the English painter Roland Penrose (1903–84), who was to become her second husband. She travelled and photographed with Penrose in eastern Europe and joined him in London in 1939. She photographed the bizarre consequences of the Blitz with a Surrealist's eye, then became the mainstay of London *Vogue*, turning out distinguished photographs across a wide range of subjects. In 1942 Lee Miller became one of six accredited women war correspondents, and the only woman photo-reporter active in combat areas, in the Second World War. She reported powerfully for *Vogue* magazine, in words and photographs, on the fighting in Normandy, the Liberation of Paris, the death camps of Buchenwald and Dachau, and the closing scenes of the war at Hitler's house in Munich.

After the war she gave birth to her son, Antony Penrose (born 1947), made photographs of her domestic townscape in Hampstead, north London, and then photographed more fully at Farley Farm, the house in the Sussex countryside where she and Roland Penrose entertained their friends – including Pablo Picasso (1881–1973), Alfred H. Barr, founding director of the Museum of Modern Art, Saul Steinberg and members of the new generation of British artists, such as the Pop artist Richard Hamilton. She became, as a finale, a *cordon bleu* cook and designer of Surrealist banquets. However, she also became – like others who had faced overwhelming events in the Second World War – an alcoholic. In another Surrealist twist, she hid away her earlier careers as model, photojournalist, writer and, of course, Surrealist – sensational achievements of which her son knew little until after her death.

Lee Miller's life resembles one of the creations of the English novelist Anthony Powell, author of *A Dance to the Music of Time*. Over the course of Powell's twelve-volume cycle, published from 1951 to 1975, characters are introduced, blaze passionately (or amuse farcically) in one role or another, returning in later volumes as apparently completely different people, unaware that most things about them have changed except their names. Lee Miller's gifts included writing, and she once described the different parts of her life as 'a water soaked jig-saw puzzle, drunken bits that don't match in shape or design'.[1] Because Lee Miller led the life and created the career she did, which were unprecedented, and because she seemed to combine male and female traits in a unique combination, no doubt she will remain a puzzle. This book and exhibition, produced to celebrate her centenary, may make better sense of the puzzle by assembling more of the pieces than ever before. For the first time, the great vintage prints have been brought together, alongside photographs by Lee Miller's mentors and those for whom she was a muse, the original magazine spreads in which her photographs were published, rare drawings and a collage, and even the final, eloquent essay she published, 'What they see in cinema' (1956), which is reprinted in this book.

Just before the end of Lee Miller's life, the first steps in the rehabilitation of those earlier lives began. Mario Amaya, director of the New York Cultural Center and curator of a Man Ray retrospective held there in 1975, conducted a long interview with Lee Miller which was published as 'My Man Ray' in *Art in America* (May/June 1975). Later that year David Travis, then a young curator at the Art Institute of Chicago, approached Miller for information about her Surrealist photographs, thirty-four of which had just come to his museum as a gift from Julien Levy (1906–81). She did not reply to his letter of September 1975 until June 1976. She asked if Travis could send 'little copies' of the photographs as 'nearly all the photos I ever took have disappeared – lost in New York – thrown away by the Germans – in Paris – Bombed and burned in the London Blitz – and now I find Condé Nast [publishers of *Vogue*] has just casually scrapped everything I did for them, including war pictures.'

Although important Lee Miller material would be donated by *Vogue* to the Lee Miller Archives set up by her son, and much remains in the archives of *Vogue*, it is also true that a great deal was thrown out. Miller was right about the extreme scarcity of her prints from before the Second World War. Many have been lost. Most of the photographs that do survive exist in only one or two copies. She wrote to Travis again in October 1976:

I hoped by this time to have gone thru a few trunks of stuff, all plainly recognisable as either pre Egypt, during Egypt... war time England... etc. You never know what might have survived... but I've been delayed, by a variety of things, mostly inertia... and in spite of considerable nagging on the part of my husband, of Mario Amaya (who wants to do a biography with and of me, stimulated by the Man Ray interview)... and an Art Historian in Paris who wants to do a show of my work... I haven't yet managed to take off on the project of digging around and thinking of the past.[2]

She never did. Although she was thrilled by Travis's exhibition catalogue *Starting with Atget: Photographs from the Levy Collection* – 'really wonderful I thought' – she was distressed by the recent deaths of her close friends Max Ernst (1891–1976) and Man Ray (1890–1976), and very unwell herself: 'that nasty Indian Goddess Kali – and the Chinese Dragon year – really wreaked havoc! I'm beginning to believe in them.'[3]

The process of recovering her photographic past from those old trunks in a Sussex outhouse might have begun earlier if she and her son had not been estranged for many years. They became reconciled in her last year, but by then she was mortally ill with cancer, and it was not the moment to rediscover her other lives. In 1977 a young Australian, Carolyn Burke, already working on her biography of Mina Loy – an earlier twentieth-century artist, beauty and muse – found herself sitting next to Lee Miller at a public event in Paris. They arranged to meet again the next day and continued their conversation. Burke decided then and there that she would follow her Mina Loy biography with a study of Lee Miller. Not long after his mother's death on 21 July 1977, Antony Penrose made the astounded discovery of her abandoned earlier lives as model, Surrealist, photojournalist and writer of searing despatches – those earlier lives that she had come to neglect as much as she had neglected him. He put his film-making career on hold to set up the Lee Miller Archives in 1980 and published *The Lives of Lee Miller* in 1985. His pioneering book not only created the foundations for later research but provided the first, expertly chosen, collection of his mother's photographs. He followed it with *Lee Miller's War* (1988) and a stream of exhibitions and publications which have stimulated further research by many other scholars, whose works appear in the bibliography – most notably Carolyn Burke, who published her invaluable full-

Lee Miller described her father, Theodore, to Mario Amaya as 'a very advanced amateur photographer', although 'his real interest was stereoptical', by which she meant that he had a passion for stereoscopic photography.[1] Stereoscopic photographs, seen through a viewer with two lenses held to the eyes, provide an astonishing, if perspectively exaggerated, illusion of physical reality. The fascination of such photographs, although entrancing to domestic audiences in the nineteenth century, waned in the face of competing illusions, such as cinema, during the twentieth. However, Theodore Miller went further than most amateurs by experimenting with projecting stereoscopic images on a screen, 'the important point', he noted in his diary, to achieve 'the true stereoscopic effect, being to get both projections focused alike'.[2] Lee grew up with such visual entertainments, as her father introduced the family to the great sights of the world in the form of commercially available stereoscopic views. She inherited much more from her father, however, than a knowledge of stereo photographs.

Theodore Miller was trained as a mechanical engineer and had risen to become superintendent of the DeLaval Separator Company, which made machines that separated liquids (such as cream from milk, but there were many other applications). The company was powered by electricity from a dynamo driven by the first turbine engine installed in Poughkeepsie, where it was the largest employer. Theodore constantly photographed his three children – Lee had both an older brother (John) and a younger one (Erik) – but his daughter was his favourite subject as a child and as a young woman. Albums record her progress from birth, the photographs taken if not daily, then usually weekly or monthly. On 14 April 1915 she posed, not only in the nude but in the *snow* outside the family house, for an artistic study titled *December Morn*. Actually, she posed twice. Carolyn Burke published the photograph in which Lee blenches from the cold, while in the other photograph – presumably the first – Lee smiles, not just gamely but beamingly, back at her father.[3] She was an enthusiastic and, in time, practised model.

At the age of fifteen she appears in overalls as a blonde tomboy on the family's farm just outside Poughkeepsie (Pl. 5). She played boys' games with her two brothers, liked tinkering with machines, used the Brownie camera her father gave her, and always liked to figure out how things worked. In fact, working with her hands was her preferred way of gathering knowledge. At fourteen she pleased her father by sending him from boarding school her design for a perpetual motion machine.[4] However, the rape she suffered at the age of seven plainly had a traumatic effect. Her brother John recalled many years later that 'It changed her whole life and attitude – she went wild.'[5] If Lee was an idle student, she was an active rebel, dismissed from many of the schools she briefly attended around Poughkeepsie. Long afterwards, as she and her husband-to-be Roland Penrose drove from New York up the Hudson Valley to Poughkeepsie, for Penrose to meet her parents, Lee pointed out all the schools that had expelled her.[6]

Lee and her father were very close all their lives, and she posed for him, often nude and sometimes with nude girlfriends too, into her twenties. Theodore photographed Lee nude with his stereo camera at home in Kingwood Park, Poughkeepsie, on 1 July 1928 (Pl. 6). By the time she began to model professionally, Lee Miller had acquired an unusually high degree of familiarity with posing for the camera. She had also become familiar, through her father, with the enchanting mysteries of the darkroom. Years later she proudly told David Travis that she herself had built her New York darkroom, including the wiring, in 1932.[7]

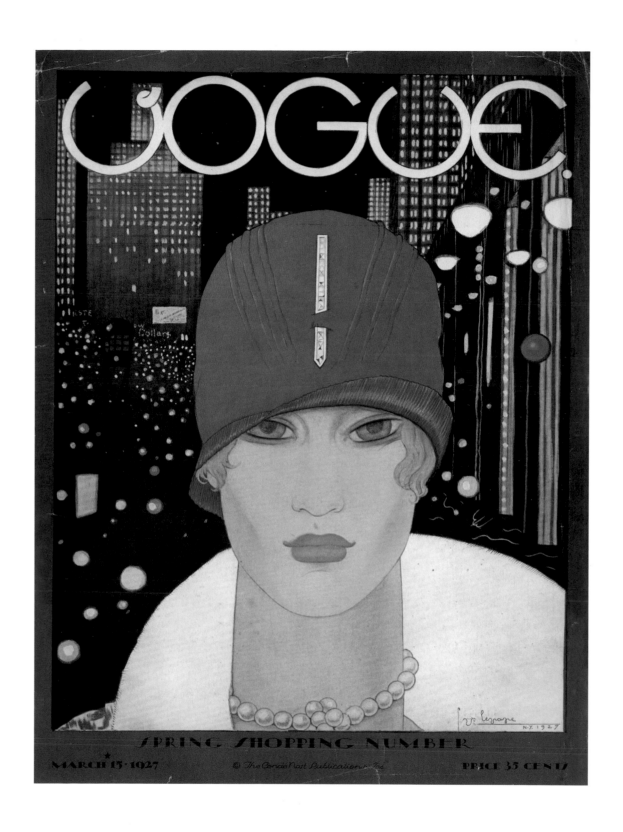

4
Georges Lepape Cover, *Vogue*, New York
15 March 1927

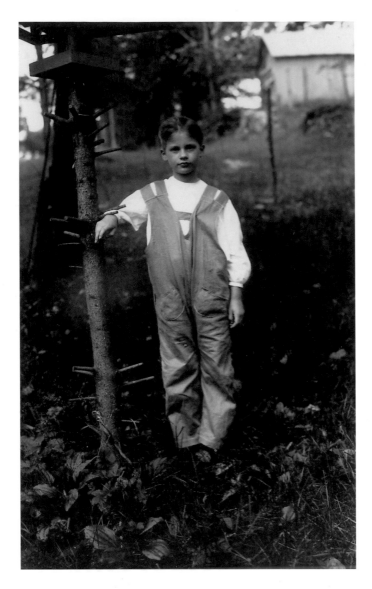

5
Theodore Miller
Elizabeth Miller in Overalls
1915

The medium Lee remembered from her childhood with greatest clarity, indeed with rhapsodic delight, however, was cinema. In 1956 she wrote an article for *Vogue* on 'What they see in cinema'. The article also tells us of the beginnings of Lee's acquisition of a repertoire of theatrical gesture, which was to serve her so well as a model. As it happened, her theatrical education began with the greatest diva of the age:

The first theatrical performance I ever attended was in the Poughkeepsie Opera House. It seems highly unlikely, but is memorable and true that the 'Bill' consisted of Sarah Bernhardt in person, playing 'the greatest passages from her greatest roles', from a chaise-longue; secondly, artistic, immobile nudes, imitating Greek sculpture (livid in quivering limelight); and as a curtain-raiser there was a guaranteed, authentic 'Motion Picture'. The Divine Sarah dying on a divan was of considerable morbid interest to me as a seven year old. Though I understood no French, her Portia, pleading, seemed urgent enough (she was propped up vertical for that); the nudes were just more ART. But the 'Motion Picture' was a thrill-packed reel of a spark-shedding locomotive dashing through

6
Theodore Miller *Elizabeth Miller Nude*
Kingwood Park, Poughkeepsie, 1 July 1928

tunnels and over trestles. The hero was the intrepid cameraman himself who wore his
cap backwards, and was paid 'danger-money'. On a curve across a chasm, the head of the
train glared at its own tail... the speed was dizzy, nothing whatever stayed still and I pulled
eight dollars worth of fringe from the rail of our loge, in my whooping, joyful frenzy.[8]

Carolyn Burke has dated the evening of Bernhardt's historic performance to 8 December 1917,
when Lee was ten rather than seven years old, but nonetheless the event – especially the one-reeler
with its heroic cameraman – made a deep impression (Burke 27). As she grew up, Lee embraced
both cinema and theatre. Her passion for and knowledge of these arts, which included a study of
theatre design and lighting, informed her career as model, cinema actress – in Jean Cocteau's
(1889–1963) *Le Sang d'un Poète* (1931) – and photographer. 'What they see in cinema' is reprinted
in this book (see p. 222), not only because it demonstrates Lee's verve and skill as a writer but
because it so amply reveals her sensibility.
 The movies gave Lee and her friends an exhilarating education in new ways to behave. Film
actresses like Clara Bow, Colleen Moore and Louise Brooks showed American teenagers how to be
'flappers' – wearing bobbed hair, cloche hats, rolled stockings, rouge and, in the words of Zelda
Fitzgerald, 'a great deal of audacity'. Fitzgerald wrote of the flapper as 'An artist in her domain'.
Her domain was simply 'the art of being – being young, being lovely, being an object'.[9] *Photoplay*
magazine breathlessly told its readers about stars, directors and young screenwriters like Anita

Loos, who began working for D.W. Griffiths when she was fifteen and later wrote *Gentlemen Prefer Blondes* (1925). Just as important for Lee and her friends, Carolyn Burke has observed, Loos 'was even better known for her dark bob – at a time when most women, especially in Poughkeepsie, had long tresses. Loos became their model.'[10] The pages of New York *Vogue* contended that the changes in fashion had very significant consequences for women and profound underlying causes:

> When women shortened their skirts and bobbed their hair, they made the most momentous change in fashion that has been made in a hundred years... In the short skirt, the beauty of a free swinging walk, of graceful length of limb, is evident. And the bobbed or semi-bobbed coiffure reveals the beauty of the head. In this way, a basis – an architectural foundation, so to speak – was set for the development of modern clothes. But as a matter of fact, conditions produce the clothes we wear, rather than any individual or group of individuals.[11]

Carolyn Burke's biography gives a full picture of Lee's engagement with theatre in her teens and early twenties. In 1923 she acted in *The Girl from the Marshcroft* and danced in *Midsummer Night's Dream*, both at the Community Theatre in Poughkeepsie. When she visited Paris for the first time in the summer of 1925, she discovered a city in which she could belong. Whereas she habitually referred to her birthplace by the unflattering abbreviations 'Pokey' or 'Pok', 'One look at Paris', she recalled in an interview in 1969, 'and I said, "This is mine – this is my home".'[12] Lee arrived in time to see the International Exhibition of Modern Decorative and Industrial Arts (often known later as Paris 25), which gave its name to the Art Déco style. Apart from the numerous halls crammed with the latest ideas in interior design and fashion, including Le Corbusier's 'Esprit Nouveau' pavilion, the Seine was dramatically illuminated: 'A glittering, nocturnal version of *Paris ville lumière* was staged at and from the Pont Alexandre III: coloured lights illuminated the bridge as well as the fountains that spurted up from the Seine. Electric lights also transformed the Eiffel Tower, turning it into a giant advertisement for Citroën cars.'[13]

Lee Miller cancelled the plan of going on to Nice with her chaperone and enrolled at one of the first schools to teach stage design. A Hungarian artist, Ladislas Medgyès, had opened L'Ecole Medgyès pour la Technique du Théâtre to teach students about lighting, costume and design. Graduates from his school took important positions in the New York theatre. Frank Crowninshield, editor of *Vanity Fair*, who visited the school that summer, where he met Lee, was impressed enough to describe its director in these terms: 'If you will roll together six of the gayest Parisian masters – Picasso, Van Dongen, Laurencin, Cocteau, Pascin and Soudeikin, you will have Medgyès ... who thinks of art as a beguiling adventure.'[14] The Medgyès school was a serious, experimental place in which the students worked as apprentices on their teachers' latest productions. Lee worked at the school and from time to time in the 'art theatres' on the Left Bank. She liked to apply herself to solving technical problems. In a notebook she kept in 1926, Lee wrote that 'Every once in a while I quite surprise myself by my actual intelligence.'[15] Carolyn Burke remarks that 'For the first time in her irregular education, she was absorbing what Medgyès called *métier* – a professional attitude towards one's craft – and learning to focus her eye while awakening to the promise of a larger life through art.'[16]

After seven months in Paris, Lee returned to Poughkeepsie. In spring 1926 she enrolled on a new course at Vassar College called Dramatic Production (DP), commencing her studies by giving a lecture to fellow students on contemporary European theatre. She was put in charge of the lighting for a production involving two electricians and six Vassar seniors, which required hands-on juggling with wires in the lighting loft to address faulty connections in the circuit, but led to gratifying recognition of her skills. She was invited to take on the lighting, together with a small acting role, for a production at the town's Community Theatre. With other students Lee regularly attended plays in New York, supplemented by visits to the art galleries. 'During the winter and spring of 1926', Carolyn Burke tells us, 'she attended fifteen productions – staged by the Theater Guild, the Moscow Art Theater, the Actors' Theater, the Provincetown Players, and the Metropolitan Opera.'[17] The plays offered more than opportunities to study technique. Plays like Eugene O'Neill's *Desire Under the Elms* connected powerfully with Lee's own inner emotional turmoil and sexual tensions – especially as she was once more under treatment for recurrent gonorrhœa and therefore sexually abstinent. A production of Ibsen's *Ghosts*, which addresses social hypocrisy about venereal disease, must also have had a particularly personal resonance for Lee.

She was welcomed as a budding lighting designer by the experimental Provincetown Players, based just south of Washington Square, and hung out with the bohemians of Greenwich Village. Despite all the social and theatrical activity, she confided in a 1926 notebook that she felt 'Void – yet full of yearning' and 'My fingers feel empty with the longing to create.'[18] All that was immediately available, however, was a spell dancing in the chorus of George White's *Scandals*, a revue on the lines of the better-known *Ziegfeld Follies*. After a short time, Lee began living in New York, working as a lingerie model at Stewart & Company on Fifth Avenue and, from October 1926, attending Life Drawing and Painting for Women at the Art Students League, at that time America's liveliest art school. Some of her fellow students became lifelong friends, such as Isamu Noguchi and the model Tanja Ramm. However, a chance encounter on a New York street suddenly opened up a new career.

As Lee later related the story, she was about to step off the pavement into the path of an oncoming car when she was pulled back by a bystander. He turned out to be Condé Nast, founder and publisher of *Vogue*, and he recognized in Lee the look of the moment. Her face decorated the magazine's cover on 15 March 1927. The artist was the most fashionable and stylish of Art Déco illustrators, Georges Lepape (Pl. 4). He portrayed her in bobbed hair under a blue cloche hat, which is pierced by an elegant diamanté pin like a miniature skyscraper, and at the neck a string of pearls knotted at the centre. Her face, illuminated as if by neon or flash, appears to be in bold command of the glittering streets of night-time Manhattan. Soon Lee had made friends with the veteran photographer Arnold Genthe, who had photographed Sarah Bernhardt twenty years before. Genthe captured Lee, hair bobbed hair as in the Lepape painting, with the last remnants of the dappled lighting of La Belle Epoque (Pl. 7). This was the style in which Genthe regularly photographed socially prominent and fashionably dressed New York women for *Vogue*. Later he made a close-up head, when Lee had already acquired the dashingly shortened hair of her signature *garçonne* look (Pl. 3), but with daringly bared shoulders. Although Lee had updated her appearance, Genthe's lighting still approximates to the twilight of romantic reverie.

Soon Lee was sitting to Edward Steichen (1879–1973), the chief photographer of Condé Nast's publications *Vogue* and *Vanity Fair*. 'For Steichen', Antony Penrose has pointed out, 'Lee was the ideal model for the mid-twenties *mode*. She was tall, carried herself well, and her strong profile and fine blonde hair exactly suited his clear, elegant style.'[19] Steichen's studio was already celebrated for its extraordinary repertoire of artificial lighting. A visitor described how the thirty different lighting appliances were 'affixed to derricks and flash down from aloft, they peek out from every corner, they can be arranged so that they actually paint the subject of the photograph'.[20] A selection of these lights bathed Lee and her gauzy sun hat to suggest the brilliance of high summer and the provocative charm of an ingénue (Pl. 8). In other photographs, Steichen portrayed her as a woman of poise well beyond her years. His 1928 study of Lee in evening dress is one of these (Pl. 9). The photograph was used, in a cropping which made Lee appear even taller and more elegant, in July 1928 in nationwide magazine advertisements for Kotex, a brand of sanitary towels: '*It has women's enthusiastic approval! The* IMPROVED KOTEX combining correct appearance and hygienic comfort,' exclaimed the copy line. Antony Penrose has remarked that 'It was the first time a photograph of a model had been used for this purpose. At that time these feminine matters were considered far too delicate to discuss and any woman who allowed her image to be used to endorse such a product was likely to be regarded as utterly debased.'[21] He adds, however, that Lee came to enjoy the notoriety conferred upon her by the ad – and it did not actually prevent her making many more appearances as a model in *Vogue*.

Lee later credited Steichen with implanting the idea that she should take up photography herself and for giving her a letter of introduction to Man Ray.[22] Her second trip to Europe, this time with her friend Tanja Ramm, began in Florence. Lee had a commission from a New York fashion designer to sketch buckles, bows, lace and other adornments in Renaissance paintings. Renaissance-inspired accessories had been one of the hits of the Paris 25 exhibition.[23] The close attention Lee paid to Renaissance paintings in 1929 was perhaps another factor in her repertoire as a model, adding to everything she had learned from her theatre studies and from modelling to New York's best fashion photographers. Some drawings by Lee will be discussed in Chapter 2. They show that she possessed facility in the kind of rapid draughtsmanship often used by designers for the theatre. This is different from making detailed copies, of course, and Lee soon resorted to a folding Kodak camera placed on a spindly tripod. Antony Penrose has noted that 'Taking close-ups in poor light with low-speed film must be about the most difficult starting point from which to explore a technique, but it was entirely characteristic of Lee to want to begin in the middle of a new skill.'[24] If Florence gave her a kind of start in photography, its great galleries – and her days at the Art Students League – persuaded her that she had nothing to offer the art of painting. She arrived in Paris in summer 1929 'fed up to the teeth with painting.... All the paintings had been painted as far as I was concerned and I became a photographer.'[25]

Lee sought out Man Ray at his studio at 31 bis rue Campagne-Première in Montparnasse, to be told by the concierge that he had left for the summer. 'You can imagine my feelings,' she recalled to Amaya, before continuing the story: 'there was a bar not far from his studio called the Bateau Ivre run by a Russian and I knew from other people that Man frequented it.' One might assume that Lee went to a bar across the way to drown her sorrows on the off-chance of meeting Man Ray – which is the way one version of the story goes.[26] Le Bateau Ivre, however, was four Métro stops

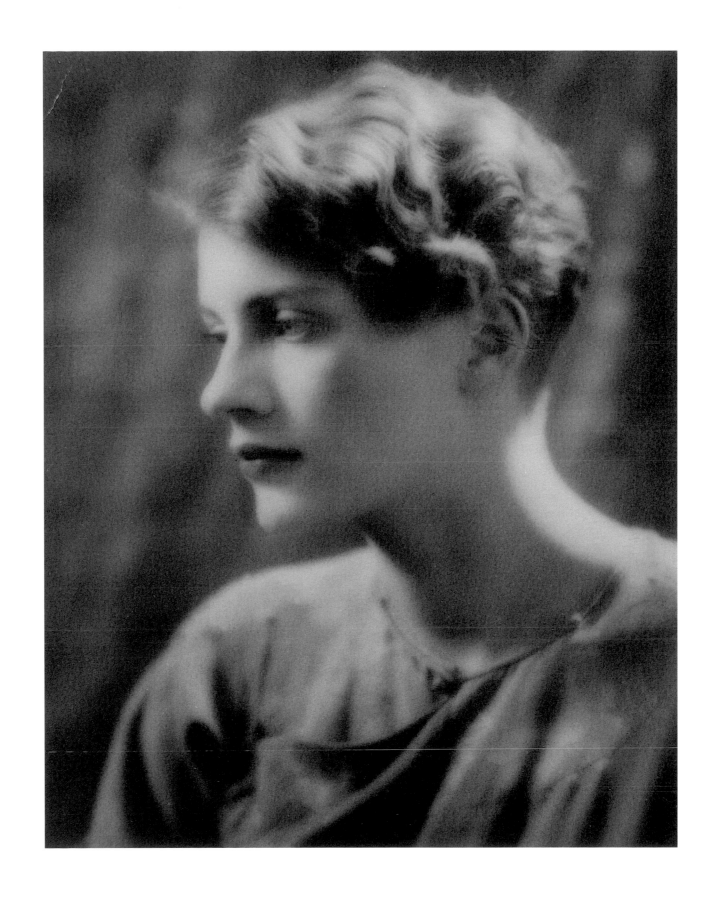

7
Arnold Genthe *Lee Miller*
1927

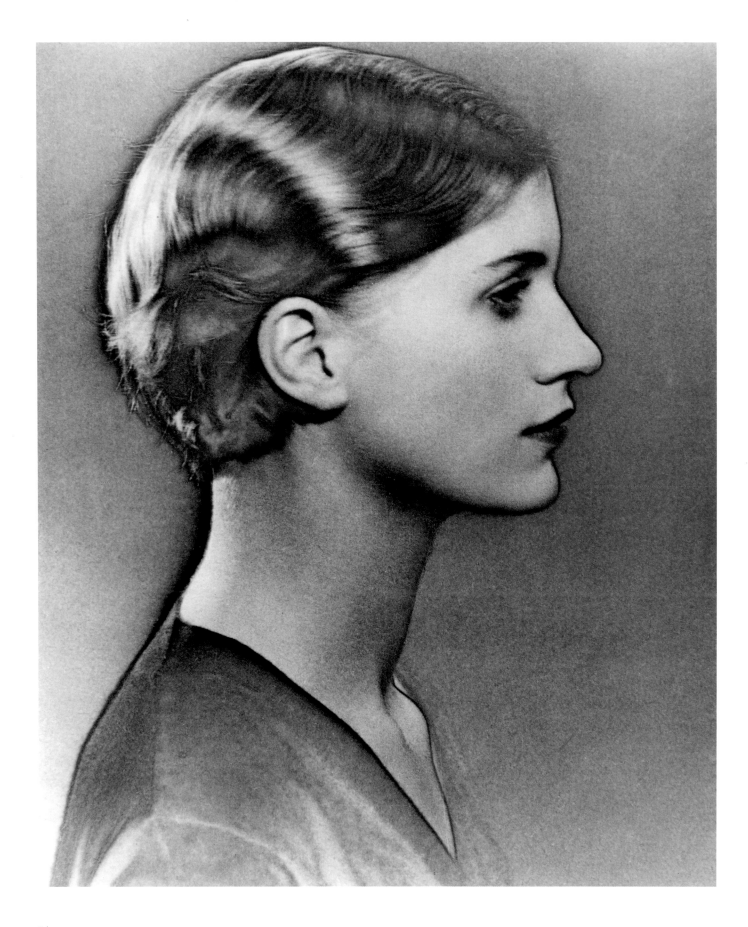

14

Man Ray *Lee Miller*

*c.*1930

In both of these the figure throws sculptural shadows on the wall behind. One of these is marked for enlargement (Pl. 11). The other two poses are closer to profiles, with a more naturalistic light; the scene could be any well-lit interior, and the expressionist shadows have gone (Pl. 12). The pose of which Lee herself owned a contact print – inscribed 'me – Lee Miller 1930' – is the one shown in Pl. 13. Her friend Tanja Ramm owned an enlargement of it, leading us to assume that this was certainly the model's preference. Of the four poses, this is the one which shows off both the hat and the jacket to their best advantage. The secret of this lies in the articulation of the figure – in the graceful contrapposto swing of the head and torso, which Lee would have seen in so many Renaissance paintings in Florence. Here the pose becomes poise, accentuating physical attributes and psychological control. If every good fashion photograph projects a role, here we see an elegant woman accustomed to command.

One of the most memorable scenes in literature in which the viewing of fashion plates is described occurs in an unlikely setting. It takes place in Moscow in the early years of the twentieth century. The setting is Levitskaya's dressmaking establishment near the Triumphal Arch:

> In the reception room the ladies clustered in a striking group round a table heaped with
> fashion journals; they stood, sat or reclined in the poses they had seen in the fashion
> plates, and discussed the models and the patterns.

This is a vignette from Boris Pasternak's *Dr Zhivago* (1958) and perhaps the gestures and garments in the fashion plates so vividly admired and emulated by the Moscow ladies were from Paris.[35] No doubt they were reproductions of drawings or watercolours. Fashion photographs made their first notable appearance in 1911, when Paul Poiret commissioned a set from Edouard J. Steichen, the most talented art photographer in Paris, before he became Edward Steichen and began his domination of commercial photography in New York in 1923.[36] Lee's career in fashion photography – first as model and then as photographer – took place in the years in which photographers had already assumed the upper hand over the draughtsmen and then gradually managed to win something of the freedom of gesture and location the illustrators had of right. It was easy, of course, for the illustrators to draw elegant young women wearing *haute couture* in bars, restaurants and hotels, the swimming pool or beach, stepping out of aeroplanes or on to golf courses. For a photographer, all these settings either involved subterfuge – as in Huené's *Divers* – or terrible logistical problems with lights, assistants, choreography and complexities akin to setting up a cinematographic shot. A revolution took place during the 1930s and, as we shall see, Lee was to make the most of the new opportunities.

Even in the studio, photographer and model had to beware of the unfortunate frankness of the camera eye, so alert to every physical blemish or momentary imposture. For example, Lee had to be careful about her hands (as she was in Pl. 13, but less so in Pl. 11). A Man Ray study in which she modelled a bathing suit in around 1930 was deemed fatally flawed by David Bailey because Lee's hands are 'too big'. Responding to this, the late Valerie Lloyd commented that 'He is probably right, but that is also what makes it an interesting picture. Lee Miller may have been one of the most beautiful women in Paris, but her hands show that she was also one of the most capable.'[37]

The collaboration between artist and model reached a peak with Man Ray's solarized portrait

of Lee in profile, one of the most celebrated of all twentieth-century portraits (Pl. 14). Solarization, also known as the Sabattier effect, had been known as an optical phenomenon – and a technical problem – in photography since its earliest period. Too great a contrast range in the subject can lead to bright areas reversing tonally into their opposite. In daguerreotypes of the 1840s, for example, a bright sky or shirt-front often reversed tonally into blue. Interestingly, the 1933 edition of the Oxford English Dictionary defines solarization only as a defect. Man Ray had by then already discovered how to control it and use it for expressive ends. His experiments were prompted by Lee, who inadvertently staged a demonstration of solarization – as she later recalled:

> Something crawled across my foot in the darkroom and I let out a yell and turned on the light. I never did find out what it was, a mouse or what. Then I quickly realized that the film was totally exposed: there in the development tanks, ready to be taken out, were a dozen practically-fully-developed negatives of a nude against a black background. Man Ray grabbed them, put them in the hypo and looked at them later. He didn't even bother to bawl me out, since I was so sunk. When he looked at them, the unexposed parts of the negative, which had been the black background, had been exposed by this sharp light that had been turned on and they had developed and came right up to the edge of the white, nude body. But the background and the image couldn't heal together, so there was a line left which he called a 'solarization'.[38]

Man Ray's imaginative use of solarization made it into a perfect Surrealist medium in which positive and negative occur simultaneously, as if in a dream. Mario Amaya thought of it as an 'almost neon effect of an outline around the figure'.[39] Professor David Alan Mellor likens it to an electric current racing in a circuit around the body.[40]

The portrait bust is cropped from an oblong film negative (8.5 × 6.2 cm), which shows Lee's torso and arm down to waist and elbow. The base of the negative includes Lee's hand, resting on some surface closer to the camera than the rest of her body; even this degree of closeness confounds the perspective, and the hand is of Brobdingnagian proportions.[41] The negative was always going to be cropped, of course, which was Man Ray's preferred way of working. His cropping in the classic version of the portrait gives the head, on its columnar neck, the solid support of the mass of the upper body. Looking closely, we can see that not even Lee's neck was quite columnar enough for the effect Man Ray had in mind and he retouched it on the negative.

The effect is not only classic but classical, part of the reworking of ancient prototypes so typical of the arts in Paris in the 1920s, from the music of Stravinsky to the paintings of Picasso to the villas of Le Corbusier. This movement was also central to fashion, internationally. We see it, for example, on the cover of American *Vogue*, for an issue on the Paris Collections, in October 1928 (Pl. 15). In April 1930 an editorial in Frogue called for 'La Fantaisie mariée à l'Esprit Classique': 'Dans son esprit comme dans sa technique, la Mode s'apparente au gout des Premiers Ages, et la Femme évoque la Déesse' ('Fantasy Wedded to the Classical Spirit': 'In its spirit as in its technique, fashion is wedded to the taste of the earliest times, and Woman evokes the Goddess').[42]

The Man Ray/Lee Miller solarized profile head restyles the nobility and gravitas of the Hadrianic Roman bust, with its tightly carved hair, replacing white marble with a much more

15
Vogue, New York, 13 October 1928

moderne effect: either an electric woman, as some think, or a goddess fashioned with the aeronautical lightness and strength of aluminium.

The finale of the Man Ray/Lee Miller collaboration appears to be the extraordinary photograph of the model's long neck, here twisted into an almost animal configuration (Pl.16). Lee told the strange story of this photograph to the Magnum photographer David Hurn at the Arles Photography Festival in 1976, the year before her death, and Antony Penrose recounted it in *The Lives of Lee Miller*:

> On one occasion Man Ray took a low-angle, soft-focus photograph of Lee's head, featuring her neck prominently. The result was not to his liking so he threw away the negative. Lee retrieved the plate and carefully made a print, working hard to enhance and perfect it until she was satisfied with the image. Man Ray was impressed, but then infuriated because Lee claimed it had become *her* work of art, not his. The row was short and furious, and ended with the usual procedure of Man Ray throwing Lee out of the studio. A few hours later, when she returned, she found the image pinned to the wall with its throat slashed by a razor and streams of scarlet ink cascading from the wound. As with so many other traumas in his life, Man Ray sought to sublimate this experience in his work. His painting *Le Logis d'artiste* (*The Artist's Abode*) shows the delicate soft neck stretching up out of a jumble of objects recognizable as the familiar clutter of the studio. The reduction of Lee's head to an object and its inclusion in this visual context reveal even more perhaps than Man Ray intended.[43]

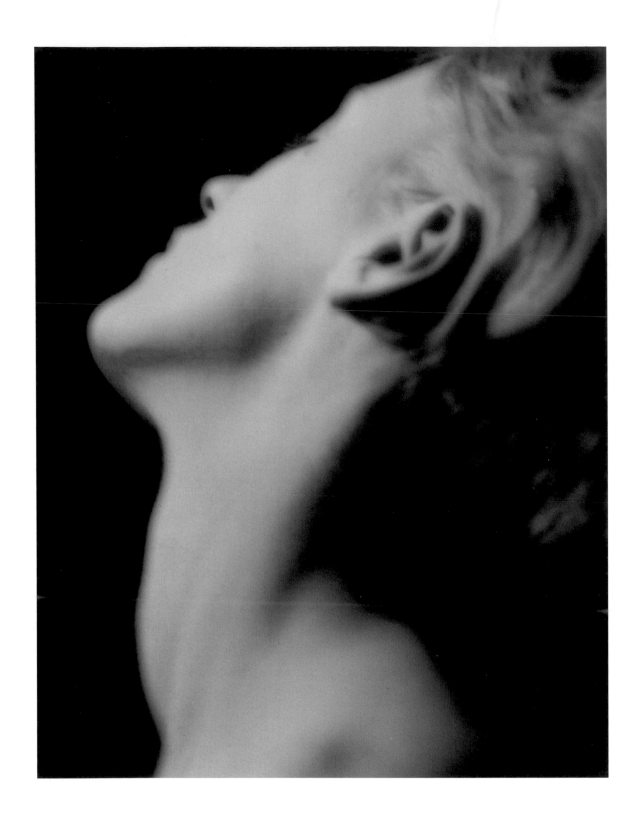

16

Man Ray (and Lee Miller?) *Lee Miller: Neck*

1929

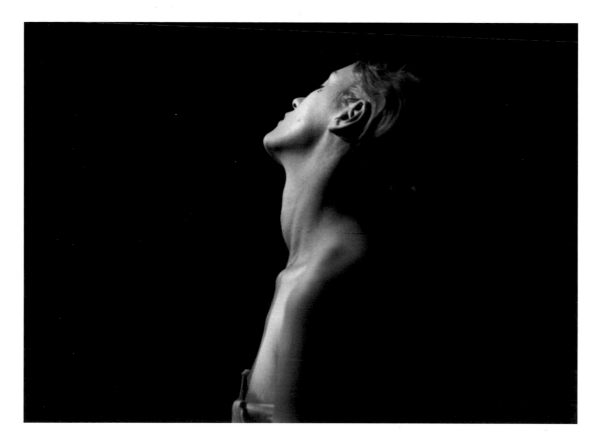

17

Man Ray *Lee Miller: Neck* (full frame)

*c.*1930

As it happens, the negative is preserved in the Man Ray Archive and shows that – as one would expect – the photograph, as printed here, was very radically cropped (Pl.17). We can see that the look of a soft-focus photograph is a result of enlargement rather than the lens used. The fact that Lee saw a photograph to be cropped out of this negative shows that she had learned very well from Man Ray.

The most spectacular of all Lee's appearances as a model was in Cocteau's film *Le Sang d'un Poète* (1931). She recalled the occasion that drew her into the film:

One night Cocteau stopped at the table where I was sitting with Man Ray at the Boeuf sur le Toit. 'Do you know anybody who wants to be tested tomorrow?' *I* did and told Man Ray so when Cocteau had moved on. Man disliked the idea, but told Cocteau anyway. The tests were marvellous: I fitted Cocteau's idea of a face.[44]

Cocteau remarked soon after completing the film that 'Hollywood was becoming a deluxe garage and all its films were more and more like sumptuous makes of automobile. With *Un Chien Andalou* [Buñuel/Dalí, 1928] we were back at the bicycle.'[45] With *Le Sang d'un Poète* Cocteau seemed to be aiming at the cinematic monocycle. He chose a high-risk strategy in which chance was not only welcomed but courted. Although he was never accepted into the Surrealist group by its 'Pope', André Breton, Cocteau's art-making was founded on improvisation and chance. As he

did not know any cinematographers, Cocteau 'sent out postcards to all the cameramen in Paris, giving them an appointment for seven in the morning. I decided to take the one who came first. It happened to be [Georges] Périnal, thanks to whom many pictures in *The Blood of a Poet* can vie with the loveliest shots of our time.'[46]

The film is, Cocteau remarked, an attempt to film poetry.[47] In so far as there is a story, it concerns a poet whose creativity is so great that the mouth of one of his creations comes to life and lives in his hand like a wound. He tries to get rid of the mouth but the sculpture he passes it on to comes to life and involves him in many strange adventures in the rooms of a mysterious hotel. There is a snowball fight – to the death – in a courtyard, a card game with Fate, a black angel, a white bull, and a fashionable audience bizarrely applauding a suicide from their theatrical box above the set.

Lee played the mouth, the sculpture – the classical theme again – and the card-playing Fate. Perhaps it is not too much to say that the film would hardly exist without her poise and fluency of movement, together with her implausible, almost hallucinatory, beauty; these were the elements with which Cocteau wove the oneiric spell of the film. He added to the unreality of his leading lady by painting eyes on her eyelids: the fact that she had to move unsighted on the set gave her, he felt, the strangeness of a sculpture in motion.[48] After many delays, on 20 January 1932 *Le Sang d'un Poète* was given a gala public opening in Paris at the Théâtre du Vieux-Colombier on the Left Bank, where Lee had worked in 1925. Cocteau's speech on that occasion was published in a small book in

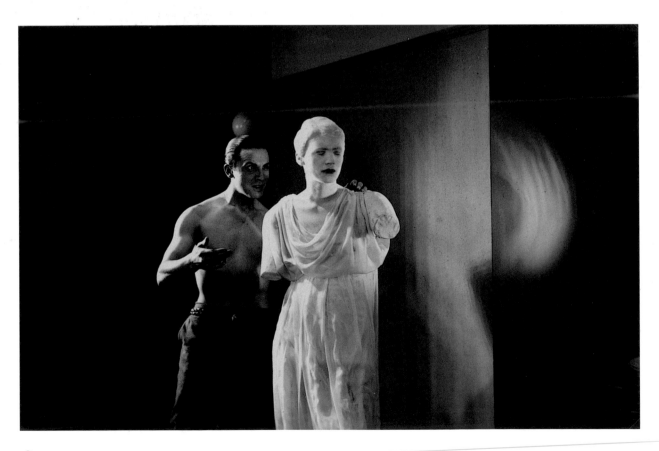

18

Unknown photographer *Enrique Rivero and Lee Miller in* Le Sang d'un Poète *by Jean Cocteau*
1931

1948, which contains stills of the production by Sacha Masour.[49] Lee's first role is as the statue, her second as the card-playing Fate, her third as a walking statue once more, shown with a bull which appears to be adorned with fragmentary patches of maps on its hide. Her finale is as a floating symbol, complete with Cocteau's signature lyre, which is perhaps poetry itself (Pls 18, 19). The often-revived film remains a classic of Surrealist cinema. Perhaps the map patches on the bull connected with Lee's sense of herself as a puzzle, and no doubt the mortal wound suffered in the children's snowball fight held an even deeper resonance. Her reverence for Cocteau's achievement shines through the remarks with which she concluded her essay on cinema in 1956:

> None of the mishaps and accidents of production found Cocteau without an
> improvisation which was to his advantage. He himself, elegant, shrill, and dedicated,
> knew exactly what he wanted and got it. He screamed and cajoled. He electrified everyone
> who had anything to do with the film, from sweepers to tax-collectors. In a state of grace
> we participated in the making of a poem.[50]

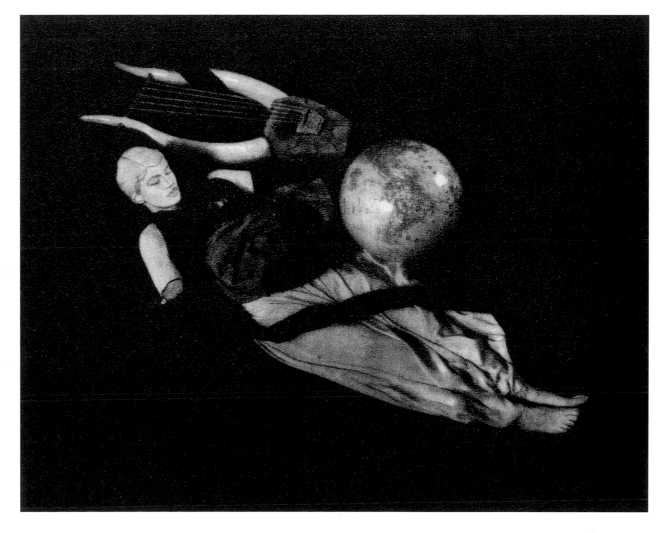

19
Sacha Masour *Lee Miller in* Le Sang d'un Poète *by Jean Cocteau*
1931

Much as Man Ray has been studied in recent years, his archive in the Centre Georges Pompidou in Paris still reveals illuminating unpublished photographs. Among them are negatives that record Lee's apartment in Montparnasse and her role as Man Ray's student. Early in 1930 Lee moved into a duplex in an apartment building at 12 rue Victor-Considérant, a few minutes' walk from Man Ray's studio in rue Campagne-Première. Man Ray photographed Lee lying on the bed in the downstairs living-room (Pl. 21). The room could hardly have been more *chic*. The angular, geometrical wallpaper was set off by rows of gramophone records – a form of decoration-cum-storage. The furniture was simple, elegant and *moderne*: a spare, tripod uplighter with a metal shade, one tubular chair and another with a generously curved back at the simple carpenter's bench desk, a bedspread with a Jean Cocteau design, a rug based – as Dr Ian Walker has noticed – on one of Man Ray's Rayographs,[1] a sculpted torso on a small pyramid-plinth, and Lee posing provocatively on the bed, dress riding up to reveal the tops of her stockings, as the sexy odalisque of 1930. Man Ray's lights have been characteristically arranged to throw large shadows on the walls, duplicating the uplighter at the left and the sculpture at the right. They also pick out Lee's face and the tantalizing paper rectangle carefully placed on the bed – a photograph, perhaps, or a reproduction of one?

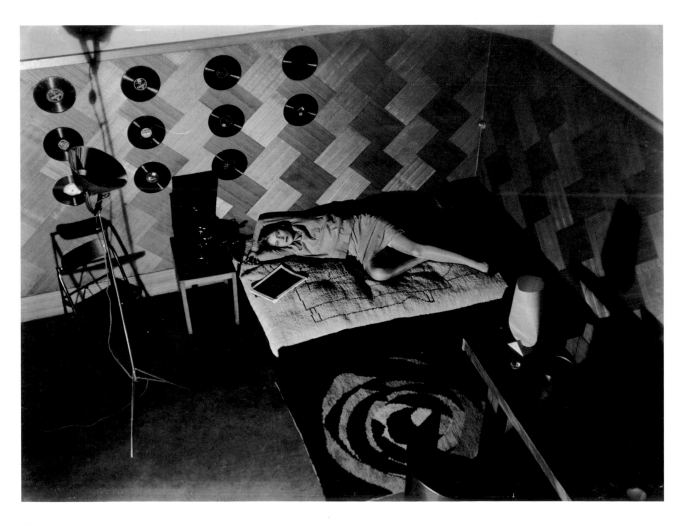

21

Man Ray *Lee Miller in her Apartment, 12 rue Victor-Considérant, Montparnasse*
*c.*1930

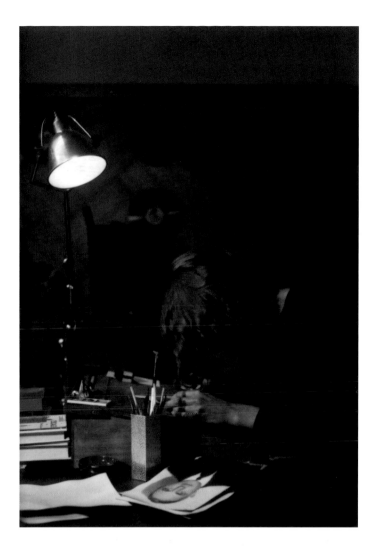

22

Man Ray *Lee Miller Retouching
Photographs in her Apartment, 12 rue
Victor-Considérant, Montparnasse*
*c.*1930

A series of three negatives in the Man Ray Archive shows Lee at a retouching desk lit by an architect's lamp.[2] In one Man Ray watches over his pupil as the proud master, an arm circling her back, and is rewarded by a flashing smile. In another he looks down at her work as if advising, one hand on her shoulder. In the third photograph Lee is alone, concentrated on her work, the desk light now switched on and a pile of portrait photographs to her left – presumably by Man Ray and awaiting retouching (Pl. 22). She described this part of Man Ray's practice in the Amaya interview. Whereas magazines would often retouch crudely with an airbrush,

> his own retouching was done straight on the print by using a little thing called a Jenner, a tiny triangular blade that went into a penholder. It was originally invented by Dr Jenner who invented vaccination and that's what he used to scratch people with. You kept this thing very sharp and if you used an eggshell paper for printing, which Man did – he had beautiful printing paper – you could very carefully scrape out a wrinkle with a very light touch, and get rid of the dark things.[3]

Retouching was only part of the technique Lee acquired. Within a year, she told Amaya, 'he had taught me to do fashion pictures, he'd taught me to do portraits, he taught me the whole technique

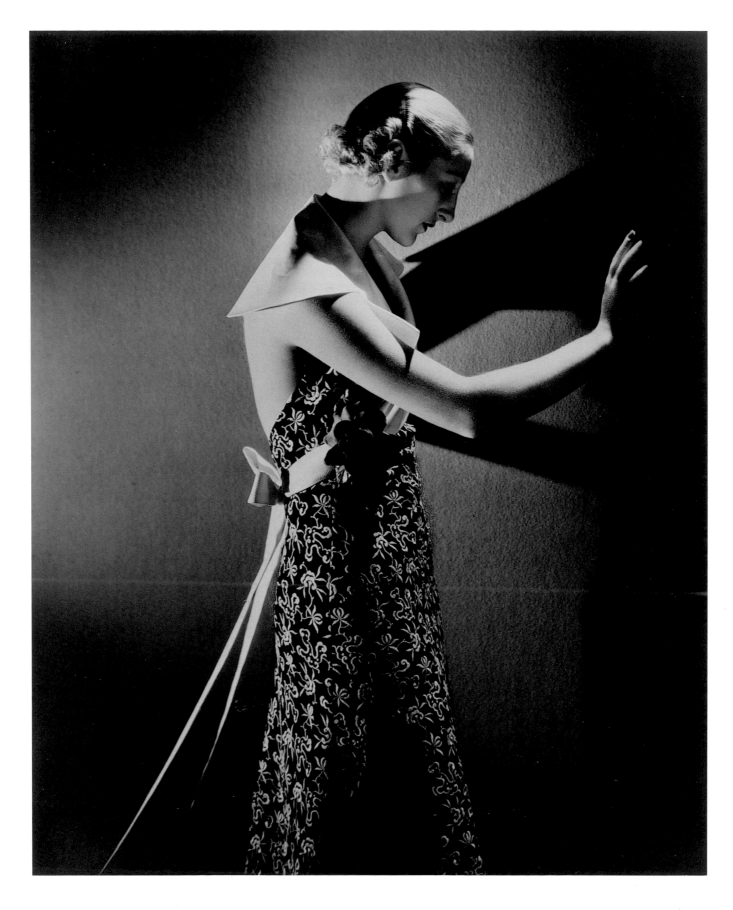

27

Fashion Study

*c.*1932

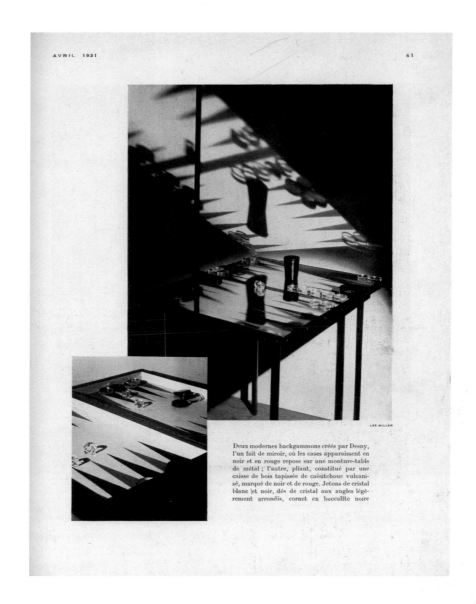

AVRIL 1931 61

Deux modernes backgammons créés par Desny, l'un fait de miroir, où les cases apparaissent en noir et en rouge repose sur une monture-table de métal ; l'autre, pliant, constitué par une caisse de bois tapissée de caoûtchouc vulcanisé, marqué de noir et de rouge. Jetons de cristal blanc et noir, dés de cristal aux angles légèrement arrondis, cornet en baccalite noire

28
Backgammon Set
Vogue, Paris, April 1931

the generally naturalistic, much more couture-conscious lighting of Hoyningen-Huené and Steichen (Pl. 27). The lighting is extraordinarily complex, as if Lee were set on trying out everything in one session. Even the model's hair is both black and blonde. Lee used her lights to create the illusion of a kind of helmet of light between hair and the collar the model was wearing.

In a Man Ray portrait of Lee's friend Tanja Ramm, her head was apparently placed inside a bell jar (although perhaps it was actually only beside it). This is an idea that can be found, as Philippe Garner has reminded me, in the domestic pre-Surrealism of commercial stereoscopic cards from the 1850s. It was revived or reinvented with substantially more edge in Paris in the 1920s. The earliest use of the idea in Surrealist circles appears to be by Claude Cahun in a photographic self-portrait from around 1925.[12] In Cahun's work, the eyes are open and engage the viewer. Man Ray's version of the idea was published in the second issue of *Le Surréalisme au Service de la Révolution* in 1930. Here the head is twisted away from the viewer and the eyes are closed. The meaning of the image is inflected by its title: *Hommage à D.A.F. de Sade*, which, as Whitney Chadwick remarks, acknowledges Man Ray's 'longtime fascination with the eighteenth-century libertine for whom the normative female body was the violated or denaturalized body'. 'Shot from below', Chadwick adds, 'and emphasising the abstract patterns of reflected light on the glass, the head resembles

became her favourite for work outside the studio. It had a ground glass, viewed looking down, at chest or waist height, which provided a clear (if laterally transposed) image of the scene. The 6 × 6 cm negative gave latitude for cropping, and the twelve negatives per roll of film offered the opportunity for trial-and-error shooting. This was the camera Lee is likely to have used to make her first independent photographs of Paris, probably in 1929 or 1930, and was to use for the rest of her career (she is pictured with the camera in Egypt in Pl. 98). A second important piece of technology arrived in 1931 – the flashbulb. This gave photographers a much more portable, and controllable, artificial light source than the magnesium powder on an open tray used – sometimes to explosive effect – by their predecessors. Photographers could also, of course, make use of photo-flood lighting for location shooting.

Lee's Parisian street photographs show her interest in the *oeuvre* of Eugène Atget (1857–1927), which she would have known through Man Ray's collection of his work and the photographs that – through Man Ray – appeared in Surrealist magazines. Atget's documentary photographs seemed dream-like to the Surrealists. In his photographs, statues and flea-market mannequins appeared to have acquired a half-life of their own. Even the most commonplace streets of Paris loomed in Atget's photographs with ancient stories and modern fantasies, like passages in a marvellous new novel about the city. In fact, that new novel arrived, just before Atget's death, in the shape of Louis Aragon's *Paris Paysan* (1926). It offers snapshots of the city with hectic, enthralled precision, like the works of the fascinated young photographers who flooded into the city at this time – talents such as the legendary figures who invented modern photography in its streets in the 1920s, André Kertész, Brassaï, Germaine Krull and many more.

Like Bill Brandt (1904–83), another young assistant in Man Ray's studio – if only for a few months in 1930 – and like her closer contemporary Henri Cartier-Bresson (1908–2004), Lee found a fertile starting point in Atget for her street pictures. She photographed statuary gesturing from shop windows and absurdly lifelike mannequins parading themselves on pavements (Pls 41, 42). Like Atget, too, she took pleasure in photographing carousel horses and cows (Pls 43, 44). Lee's photographs treat the sculpted animals as creatures come to life, as of course they do in the imagination of the children who ride them. The photographs remind us of the centrality to Surrealism of the child's imagination, which innocently overrides adult 'reality'. These photographs also recall an essay on carousels by Joseph Roth, the observant Paris correspondent of the *Frankfurter Zeitung*. Roth's 'The Child in Paris' celebrates the remarkable privileges – to his central European eyes – accorded by the French to their children: 'This people, that makes and bears so few children, not only respects the child as the future of the country, the nation, the world – it quite unthinkingly loves it, the child as creature, the becoming person who is still half an animal.' He saw the carousel, that touchingly omnipresent feature of French parks and squares, as providing 'a game, a sport, that very subtly helps to train the child to be self-aware'.[20] Lee's photographs also play games. She points to a dark horse cantering beside the 'real' one, and her angle of view stampedes carousel cows into Pamplona bulls.

Lee photographed Paris in many ways – with amusement, pleasure and lyricism – but also with the radical doubt of a Surrealist. Surrealism was the local, initially Parisian, branch of a much wider scepticism that affected the generation that experienced the First World War. It was a way of experiencing before it became an artistic school. Joseph Roth is, once again, an eloquent witness:

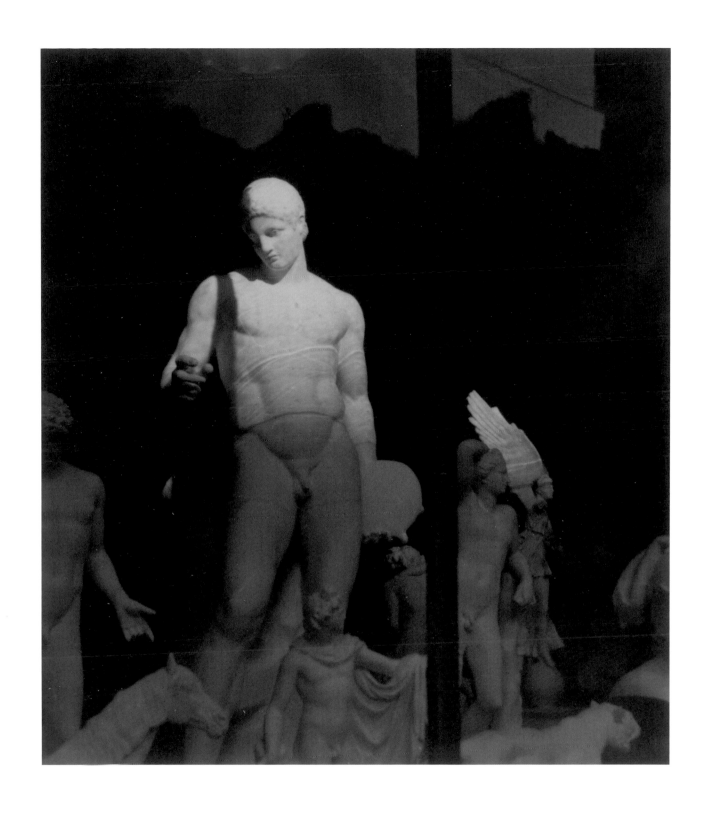

41
Untitled [Sculpture in Window]
1930

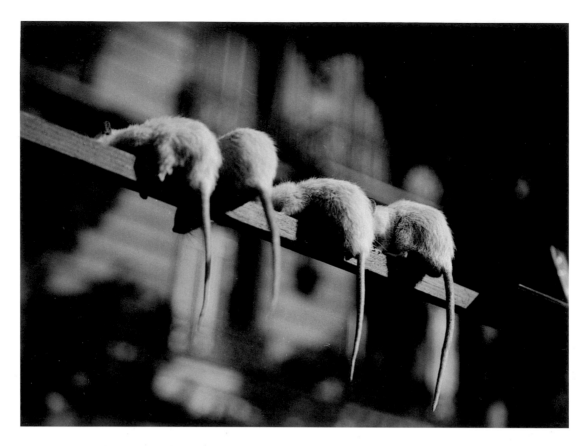

45
Untitled [Rat Tails]
c.1930

Se retrouver dans un état d'extrême secousse, éclaircie d'irréalité, avec dans
un coin de soi-même des morceaux du monde réel.

. . .

Une espèce de déperdition constante du niveau normal de la réalité.

(To find oneself jolted to an extreme, lit by the unreal, with, in a corner
of oneself, fragments of the real world.

. . .

A kind of constant displacement of the normal level of reality.)[22]

Lee took delight in detaching rectangles of reality from the contexts that ordinarily determine their meaning. She photographed white rats perched side by side in formation, presumably on a stall in the market for domestic animals on the Quai aux Fleurs (Pl. 45). She carefully photographed birdcages set on a balcony, set high, it seems, above one of the boulevards – a reflection on security and imprisonment which chimes, perhaps, with her carbon-paper drawings (Pl. 46). She made empty, abstract photographs of interiors (Pl. 47) and teasing details of architecture that have been identified by Carolyn Burke as Lee's apartment building at 12 rue Victor-Considérant (Pls 48, 49).[23] There are disorientating views of café chairs and studio props, including Man Ray's familiar sabre guard (Pls 50, 51).

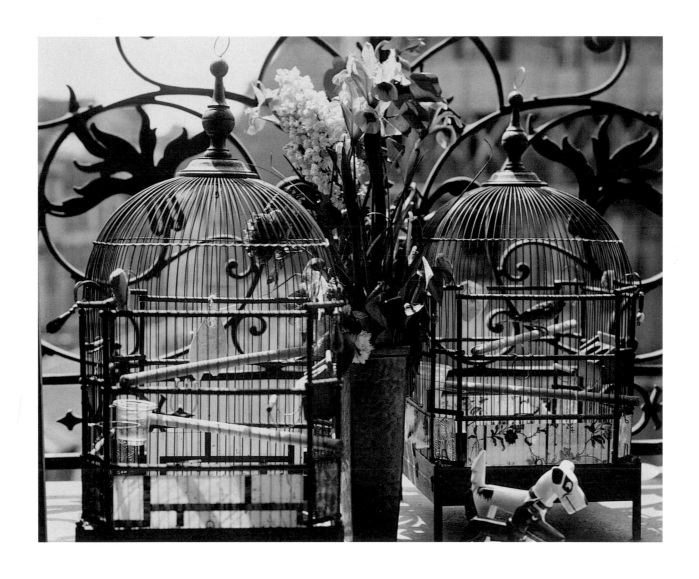

46
Untitled [Birdcages in a Window]
1931

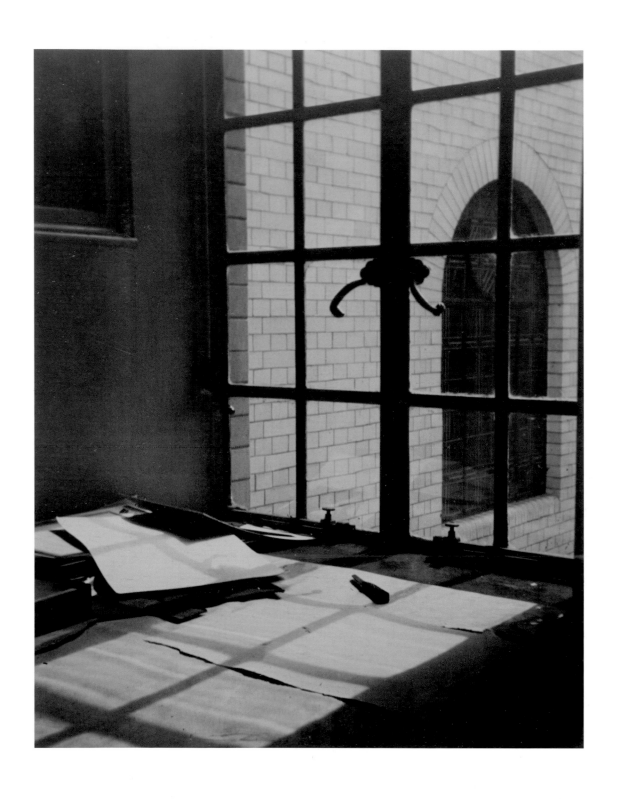

47
Untitled [Window]
*c.*1930

There is no obvious stylistic prototype for these photographs, although they bear some resemblance to various semi-abstract photographs from the late 1920s by the Dadaist Raoul Haussmann. Some of the more elegant abstractions are reminiscent of similar experiments made by the New York photographer George Platt Lynes at Coney Island in the late 1920s.[24] There is also a certain affinity with the snapshots taken at weekends in the years 1930–37 by the painter Fernand Léger and his friends Charlotte Perriand, the designer, and Pierre Jeanneret, the architect. Their photographs of found objects, nautical geometry, odd industrial surfaces, plus water, earth and random sculptural shapes have a generic title. It was provided by Le Corbusier, who also experimented in this vein: 'Les Objets à reaction poétique'.[25] Although the generic title suits some of Lee's photographs of similar subjects very well, hers were more carefully framed than snapshots and altogether more ambitious. They were also enlarged, printed on Man Ray's good 'eggshell' paper, mounted, signed and later – as we shall see in Chapter 3 – exhibited.

Perhaps the most remarkable of Lee's semi-abstract close-ups is a pair of asphalt photographs (Pls 52, 53). Such photographs remind one of the place of asphalt and 'formlessness' generally in Dadaism: 'The Dadas took on a new perspective on shapelessness, on ordinary and prosaic objects, things which flatter neither the eye nor the touch. A dismantled lampshade, asphalt from the road, driftwood, a till receipt – all these are deviated from their original purpose.'[26] Man Ray contributed to the genre in various films and such collages as *Transatlantique* (1920), which features a photograph of an upturned ashtray.[27] However, Lee's photographs are artistically independent of their possible forerunners. In one of her photographs, asphalt poured across a street has dried into a spiky biomorphic form, as if a Giant Ray has been cast up on an urban beach. In its companion piece, a pair of well-polished shoes and pressed trousers, signifiers of the Magrittean Everyman, stand beside the same mysterious form, perhaps in astounded self-analysis – for the asphalt has taken on the indeterminate configuration of a Rorschach test.

If Lee made use of degraded, Dada materials in some works, other photographs from the Paris period feature a favourite focus of Surrealist art, the human hand. We see it gesturing in silhouette under a café umbrella, arranging blonde curls at the back of a woman's head and gesturing in priestly form from a high balcony (Pls 54–6). The priests may be admonishing an unseen congregation or perhaps the heavens. We also see a multiplicity of painted and 'real' hands in a surprising photograph which makes a mother and child seem to assist at a (painted) surgical operation (Pl. 57). The climax of this series is a work that has come to be known as *The Exploding Hand*. The photograph is one of three (all in the Lee Miller Archives) made in front of the Guerlain parfumerie in Paris. Two are angled views of the fascia, shop windows and tree reflections. The most celebrated photograph of the three shows an elegantly sleeved hand clasping the door-handle (Pl. 58). The contact sheet of this shoot shows that Lee photographed the Guerlain windows to capture as much visual complication as possible – mixing up bits of the interior, the window surrounds and reflections in the plate glass. A contact print shows how deftly she composed the final image (Pl. 59). She cropped the picture tightly to concentrate on the 'exploding hand'. The strange electrical flash on the door was apparently caused by the scraping of countless diamond rings on the glass beside the door handle. Here Lee achieved that 'convulsive beauty' identified by André Breton as the hallmark of Surrealist art.

There is a dynamic intensity about other views of the city, for example the silhouetted wheels

48
Untitled [Architectural Study]
1931

49
Untitled [Ironwork]
1931

50
Untitled [Chair]

1931

51

Untitled [Wire Sabre Guard with Photographic Equipment]

*c.*1930

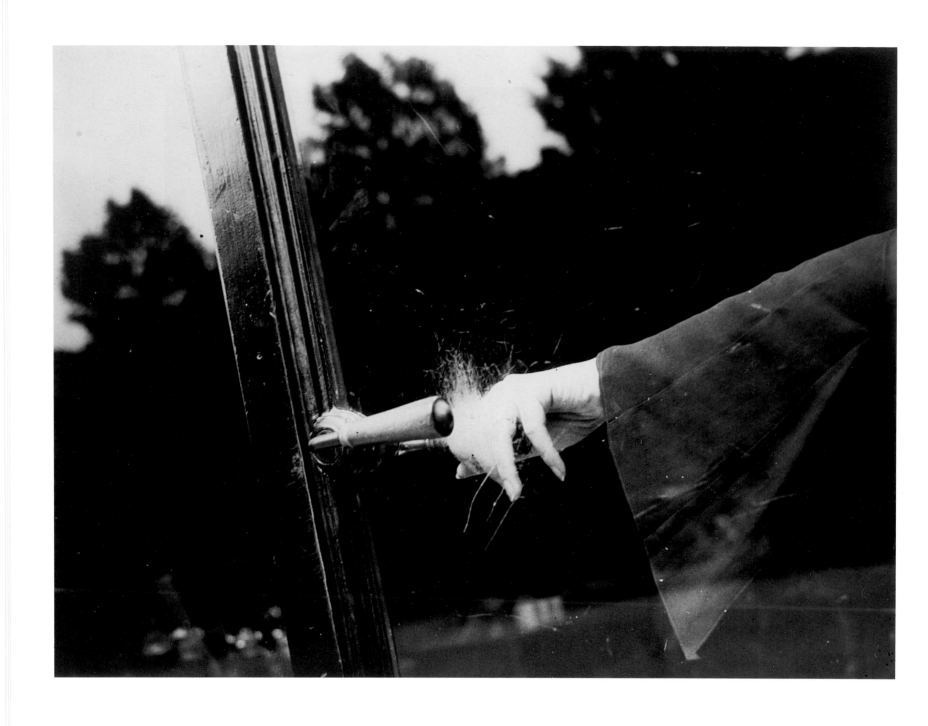

58

Untitled [Exploding Hand]

*c.*1930

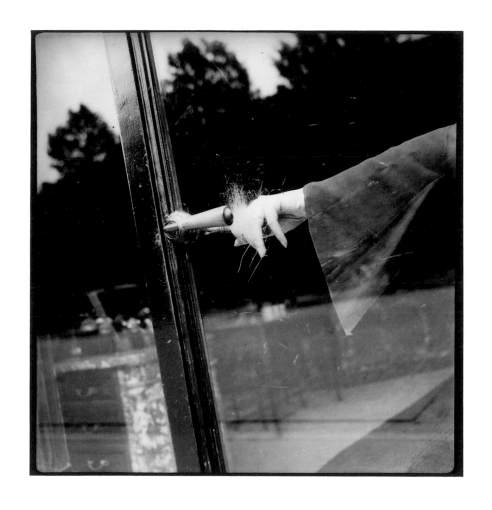

59
Untitled [Exploding Hand]
contact print, *c.* 1930

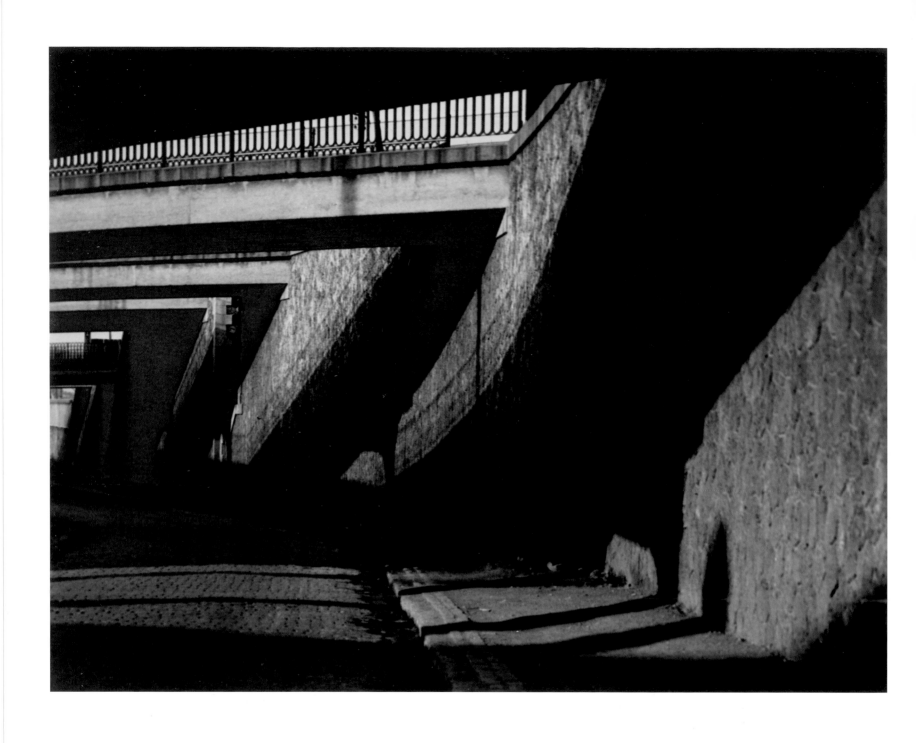

61

Untitled [Street Scene]

*c.*1931

62

Untitled [Street Scene]

*c.*1931

3 New York 1932–34

Self-portrait in Headband
Published 1933

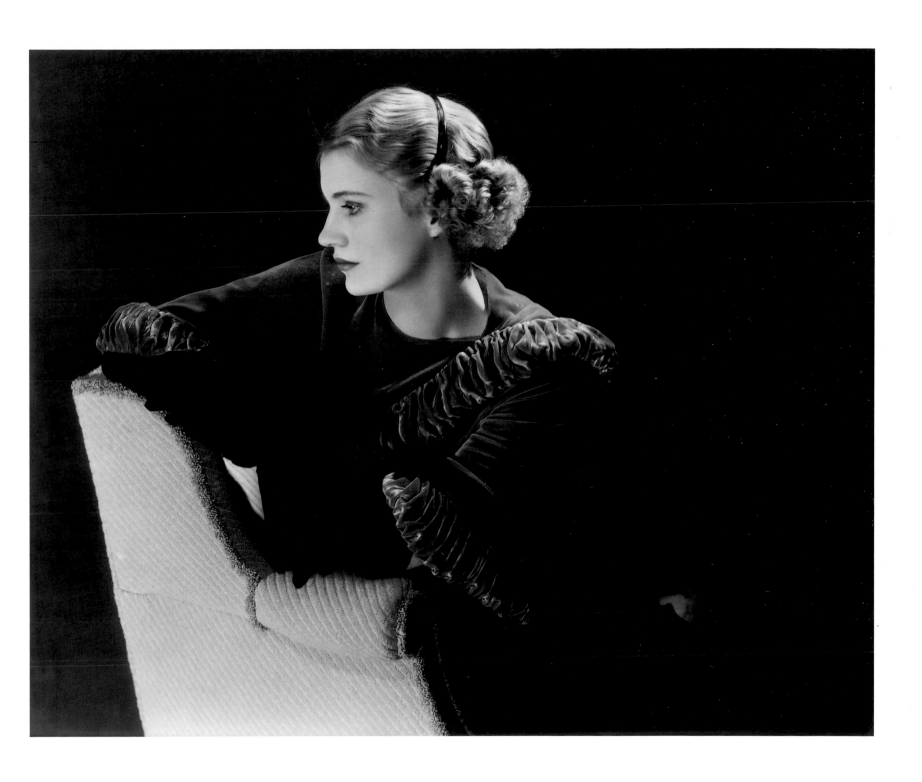

On her arrival in New York in October 1932, Lee told a reporter that she would 'rather take a picture than be one', that photography gave her 'the joy I wanted from my work' and that it suited 'the tempo and the spirit of today'.[1] In partnership with her younger brother Erik, she set up Lee Miller Studios at 8 East 48th Street. Erik was capable, interested in photography, and was later to become chief photographer for the Lockheed Corporation, where he excelled in air to air photography, which required him to hang out of the back turret of a modified bomber. The Lee Miller Studio was backed financially by Cliff Smith, heir to the Western Union fortune, and Christian Holmes, heir to the Fleischmann Yeast fortune and a Wall Street broker. They floated the studio on a share capital of $10,000 and enabled Lee to lease two apartments in the six-storey building. Lee used one of the two third-floor apartments, which were separated by a kitchen, as her own. The other was the studio. They installed cypress-wood developing tanks for 8 × 10 inch plates. The cables for the studio lights were concealed and were operated from a remote switchboard. Lee created an elegant, feminine ambience appropriate for the business of portraiture. A reporter noted that Lee 'decorated the windows with tubes of chiffon in the shades of the spectrum, like a row of Christmas stockings. The French doors [were] treated with the same tints in flat curtains.'[2]

Lee later recalled that November 1932 was not the greatest time to open a new studio, that many of the commissions she had secured before leaving Paris had been cancelled by the time she reached New York, and that she had to work on cut-price rates to stay open.[3] However, on the credit side, Lee and her brother had the support of their investors, a web of media connections and her very well-known face and name. As it happened, two most elegant fashion photographs of Lee were on the news-stands when she returned to New York. She appeared in American *Vogue* for 1 October 1932 modelling a Jeanne Lanvin black wool evening dress and *paillette* – a small cape of turquoise beads studded on tiny steel disks. Although Lee was credited in the caption, the photographer was not – it was doubtless Hoyningen-Huené. In the 15 October issue his celebrated shot of Lee under the studio lights (Pl. 23), which had already been seen in Frogue and Brogue (British *Vogue*), now made it on to the editorial page of American *Vogue*. Whereas Frogue had used the photograph to celebrate the rigour required by elegance, here the caption rhapsodized on the heroic artifice of the fashion photograph itself:

> we are permitting you a look-in at a fashion session in *Vogue*'s studio. You, who generally
> see only the immaculate result, the finished photograph, will be slightly astounded by
> this: already a dozen dresses have been tried and thrown out; she who wears them is the
> final choice of a parade of beauties who failed to please; behind a screen hovers a florist
> with flowers kept fresh for the psychological moment, also a detective armed to the teeth,
> protecting the jewellery used; an editor is pinning the ultimate dress just right; a group of
> assistants are fiddling with lights; while off in a corner, the photographer is quietly
> praying to himself.

That was Lee's impressive finale in *Vogue* as a model performing for its fashion photographers, though not – as we shall see – her last appearance in its pages as a model. Her own photographs were soon being published in *Vogue*. She made a confident début on 1 February 1933 with an elegantly lit Mrs Livingston Potter, wearing 'a charming ruff of Coq feathers' (illustrating an article

titled 'For Love or Money – Parties to Remember').

Lee's studio also had as an asset the friendship of major New York photographers, who passed on jobs from time to time. Lee mentioned Nickolas Muray, who had photographed her five years before, as being especially kind. She had a staff of three: Erik, a studio manager and a cook – for sitters who required reviving with a snack. She also had undoubted self-belief. Lee told a reporter that photography is

perfectly suited to women as a profession…. It seems to me that women have a bigger chance at success in photography than men…. Women are quicker and more adaptable than men. And I think they have an intuition that helps them understand personalities more quickly than men.

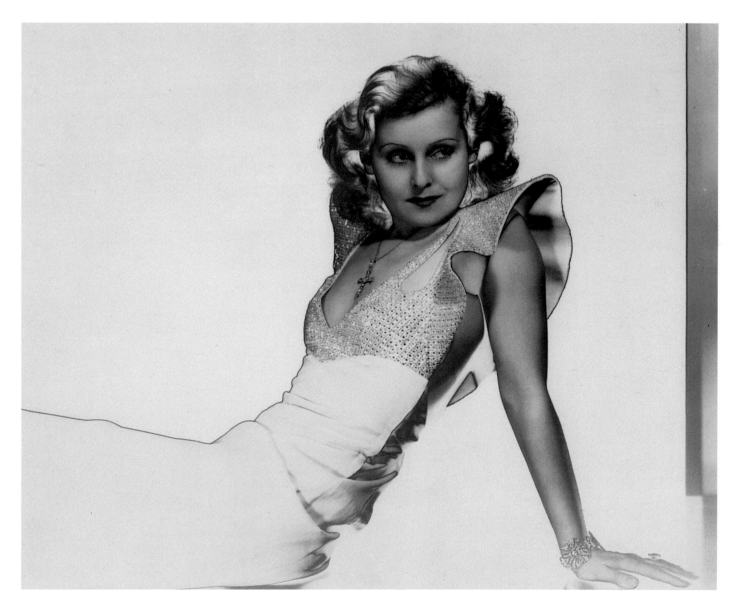

74
Solarized Portrait of Lilian Harvey
1933

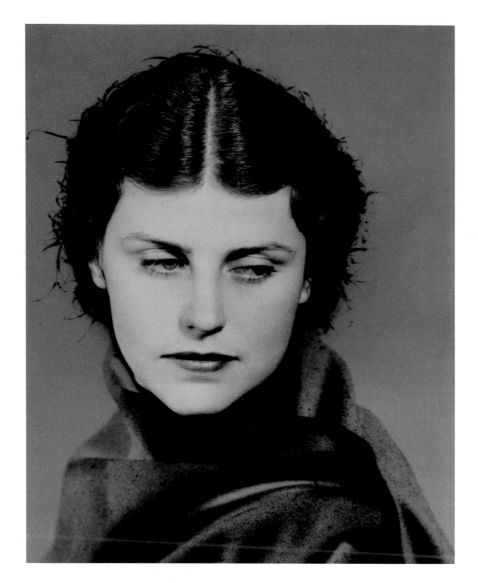

75
Solarized Portrait of Dorothy Hill
1933

A good portrait, she remarked, catches its subject 'not when he is unaware of it but when he is his most natural self.'[4]

Although her studio was more elegant than her master's, Lee advertised it as the American branch of 'the Man Ray school of photography' (Burke 129). Some works from the New York period confirm her prowess in the technique of solarization, including several accomplished portrait studies. Among these are portraits of the silent movie star Lilian Harvey (Pl. 74) and two wedding portraits of Dorothy Hill (Pls 75, 76), a friend of Tanja Ramm. Hill is shown draped from the neck downwards in the fabric familiar from some of Lee's Paris portraits. Other portraits make striking use of Man Ray's predilection for the head floating in isolation on a black background, as in Lee's portrait of Mary Taylor (Pl. 77). The refined portraits of Dorothy Hill, like a number of others from the New York studio, were printed on the matte 'eggshell' paper favoured by Man Ray. In general, however, the New York photographs are printed on a glossier stock more similar to the papers used by Edward Steichen. We cannot be sure whether this choice of papers was simply a matter of

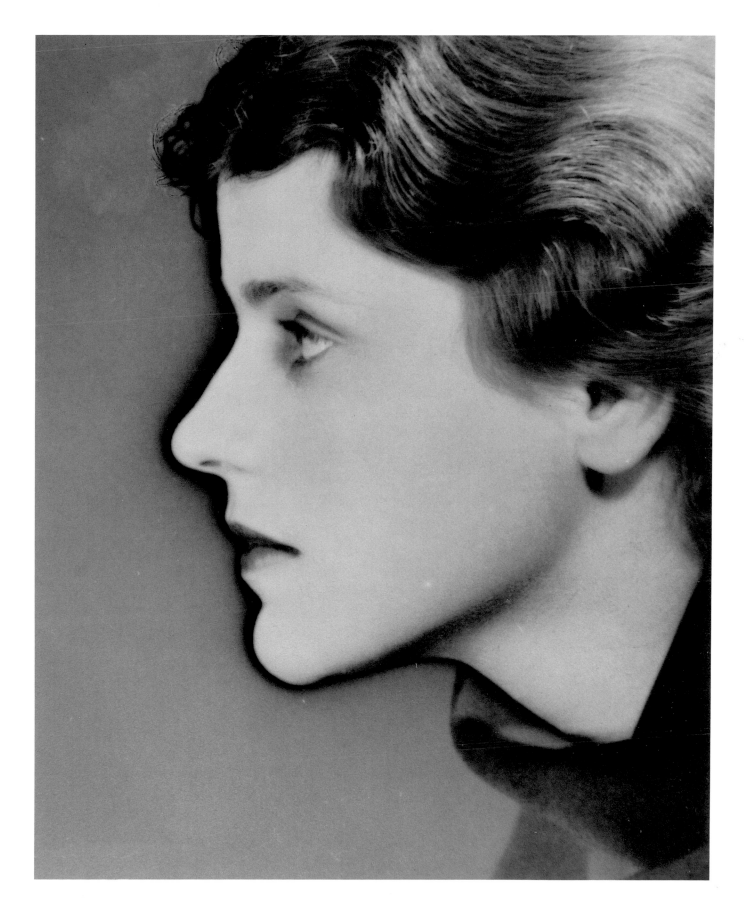

76

Solarized Portrait of Dorothy Hill (Profile)

1933

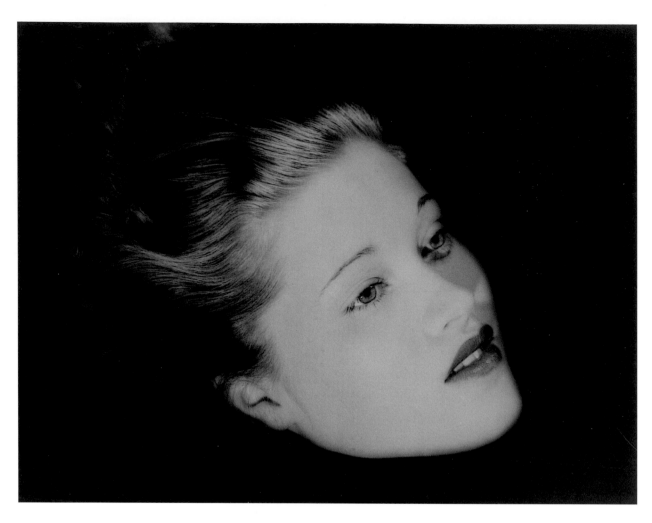

77

Floating Head (Mary Taylor)

1933

working with what was commercially available or of making a self-conscious move from the ambience of Parisian art photography to that of a professional studio in Manhattan.

Lee also carried out a surprising experiment in solarization featuring what appears to be a toy-sized model piano (Pl. 78). Possibly it was made of silver, which is perhaps why Lee chose to solarize it, as the technique evokes the appearance of a metallic sheen not only on faces but also on objects. Lee recalled that one of the many lessons she learned from Man Ray concerned photographing silver:

> that's one of the things he taught me so carefully, how to photograph silver objects
> because where you think a silver object is very bright, it actually isn't, it's just reflecting
> what's in the room which may be black, green, red or whatever. Quite an elaborate
> business to photograph in those days.[5]

The studio's clients, Lee recalled, included advertising agencies such as BBDO and Henry Sell, plus fashion, cosmetics and toiletries companies like Elizabeth Arden, Camay, Helena Rubinstein, Saks Fifth Avenue, Jay-Thorpe and *Vogue*. She also carried out portrait commissions for Warner

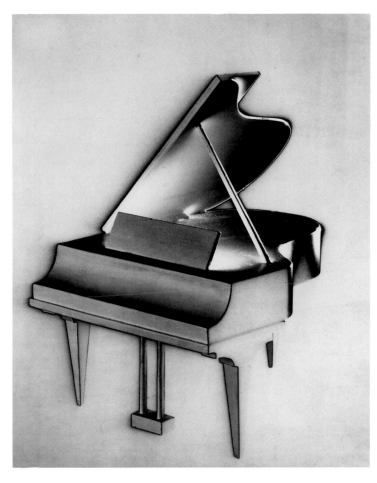

78
Solarized Piano
1933

Brothers and various theatre companies. In the way of such assignments, she recollected, 'very little of my work in New York was signed ... advertising very rarely is ... although Jay-Thorpe always was and some other fashion accounts.'[6] She was credited not only by Jay-Thorpe but also by such well-known fashion stores as I. Magnin & Co, Hattie Carnegie and Fortnum & Mason (who had a store on Madison Avenue as well as on Piccadilly, London). She showed commercial enterprise by photographing Tanja Ramm being fitted for her wedding dress; this was used by Bergdorf Goodman to promote its bridal shop but also featured in an advertisement by Wallace Silversmiths – purveyors of wedding gifts – in *Vogue*.[7]

The few examples of Lee's advertising photography that survive as photographic prints show her skill in this field. A packaging shot for Mary Chess cosmetics uses a soft paper to emphasize the products' soothing qualities (Pl. 79), whereas a shot of Elizabeth Arden scent bottles takes a different approach (Pl. 80). Here the clarity of the unblemished glass vessel vouches for the purity of their contents, their presence doubled by the flawless reflections in the mirror-glass on which they are ranked. She also contributed to *Creative Art*. In January 1933 the New York journal, which at that time included Alfred Stieglitz on its editorial board, featured Lee's photographs of the Vanderbilt Residence and Tiffany Mansion. She photographed the Russek Building for the magazine's May issue. In 1932–3 the magazine carried regular articles on major New York

photographers, including Paul Outerbridge, Charles Sheeler, Edward Steichen and Ralph Steiner. In New York in the 1930s there was a serious understanding of the art of photography, in its manifestations as both fine art and fashion, and Lee was recognized as part of the new wave of photographic talent. Her reputation was fostered by a remarkable gallerist.

Julien Levy was from a wealthy New York family. Levy's memoir *Portrait of an Art Gallery* (1977) has recently been augmented by *Documentary and Antigraphic: Photographs by Cartier-Bresson, Walker Evans & Alvarez Bravo* (2004), which reconstructed one of Levy's most prescient exhibitions, held in New York in 1935.[8] He studied at Harvard in 1923–7, became fascinated by photography and film, met Marcel Duchamp and travelled to Paris to make an experimental film with Man Ray. Although the film never saw the light of day, Levy frequented Parisian avant-garde circles. Through Man Ray he acquired photographs from Atget. In Paris, he met and married his first wife, Joella, daughter of Mina Loy. He played a key role, with Berenice Abbott, in preserving Atget's archive after the photographer's death in 1927. In the same year he met Henri Cartier-Bresson for the first time. He returned to New York with his wife and, under the influence of Alfred Stieglitz – doyen of international art photography – opened a gallery at 602 Madison Avenue in 1931. 'When I decided to open my own gallery, I decided to experiment: to pioneer in photography and to see if I could put it across as an art form, and make it perhaps pay enough to support the gallery.'[9] For the next five years Julien Levy played a far more important role in the exposure of photography

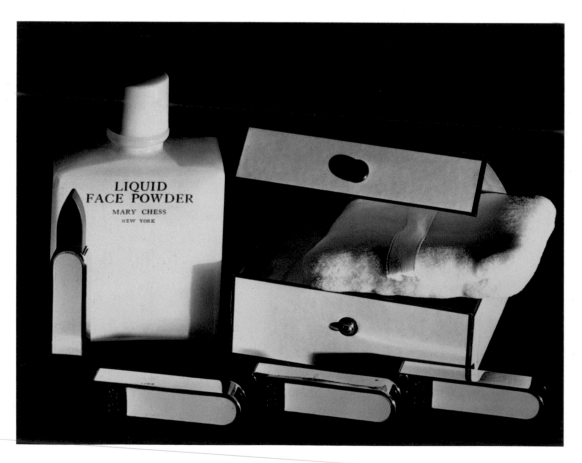

79
Mary Chess Cosmetics
1933

80

Scent Bottles

1933

81
John Rodell
1933

and film than the Museum of Modern Art (founded 1929). Levy's was also the first gallery in New York to promote Surrealism. The front gallery was painted white and the back one red. According to Ingrid Schaffner, Levy 'installed an inventive system of wooden mouldings designed to hold photographs sandwiched between reusable sheets of glass'.[10] His first exhibition, a homage to Stieglitz, traced the evolution of American photography from Pictorialism to the 'straight' approach. The next was a first solo show by Walker Evans, followed in February 1932 by *Modern European Photographers*. This displayed Lee's work alongside photographs by Man Ray, André Kertész, Ilse Bing, Florence Henri and László Moholy-Nagy. A critic for the *New York Times* praised Lee for contributing 'two of the most striking pictures in the show, the Greek statue with its

82
Mr and Mrs Donald Friede
c.1933

dramatic spotlight effect [presumably Pl. 41] and the study of a pink-nailed hand embedded in curly blonde hair' (see Pl. 55).[11]

Levy followed this up with a solo show of Man Ray photographs, which featured the solarized profile of Lee (see Pl. 14). He also lent Lee's photographs to the Brooklyn Museum's *International Photographers* exhibition in spring 1932, where she showed alongside not only Man Ray, Moholy-Nagy and Henri but also Berenice Abbott, Cecil Beaton, Margaret Bourke-White, Imogen Cunningham, Walker Evans, George Hoyningen-Huené, Tina Modotti, Edward Steichen, Maurice Tabard and Edward Weston. In November 1932 her work appeared in a mixed exhibition of portrait photographs at the Levy Gallery. A reviewer in *Creative Art* drew attention to Lee's 'fresh portraits of Massimo Campigli and Eugene Berman', both of whom were Levy Gallery artists.[12] Lee's portraiture demonstrates a wide range, from the concentrated elegance of Dorothy Hill to the cinematic melodrama of the literary agent John Rodell (Pl. 81) and the engaging intimacy of the double portrait of Mr and Mrs Donald Friede (Pl. 82). Among her most successful portraits is a tightly composed head of the boxer Gene Tunney, whose victory over Jack Dempsey in 1926 made him Heavyweight Boxing Champion of the World (Pl. 83). The simplicity of the pose, with its concentration on the undefeated champion's dignified head, showed that Lee knew when restraint was best.

Lee's own first – and last – solo exhibition was on show at the Levy Gallery from 30 December 1932 to 25 January 1933. No checklist of the exhibits appears to exist, but the exhibition

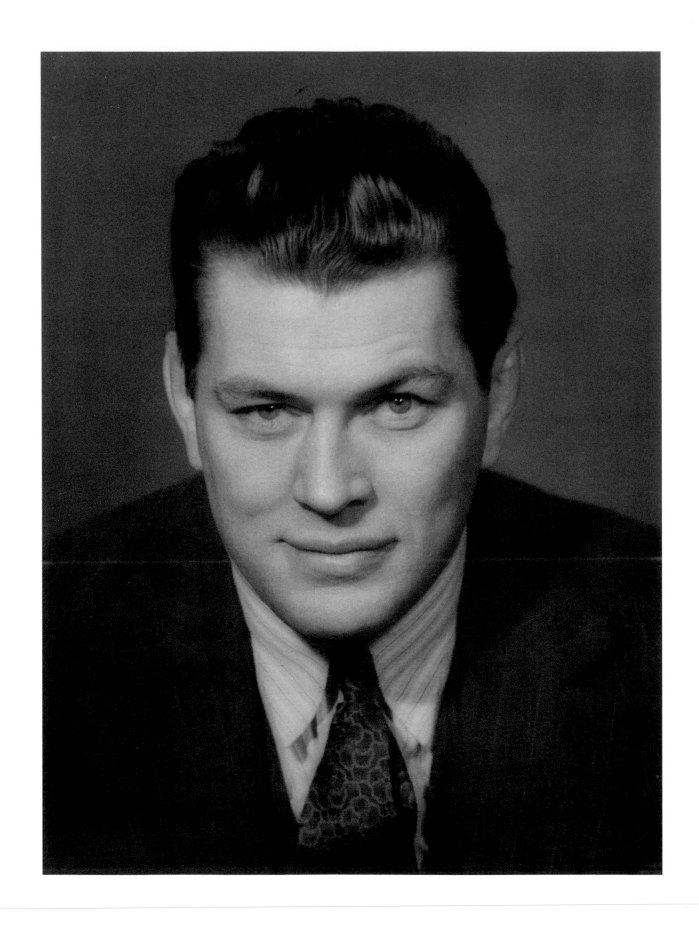

83
Gene Tunney
1932

announcement and reviews suggest that the show included Parisian street scenes, architectural studies, still life and portraits. The announcement carried an endorsement from Frank Crowninshield, editor-in-chief of *Vanity Fair* and a major collector. 'Crowny', as he was known, had met Lee when he visited the Medgyès school in Paris in 1925. He collected artists such as Braque, Matisse, Modigliani and Picasso, 'without whom', he said, 'there would have been no record left to the future of the violent change of soul that has taken place during the seventeen years since the war'.[13] He wrote that Lee had left New York for Paris as 'a girl in her earliest twenties. She has now returned... an accomplished artist.' He referred to her apprenticeship 'with the artistic radicals of France, the Surréalistes, and their photographic leader, Man Ray, as well as her gift for seeing artistic possibilities in all sorts of subjects'. He saw photography as a medium in which Lee 'has shown herself naturally and peculiarly adept'.[14] Levy hailed Lee at the opening as 'the new light on the horizon of photography'. Edward Jewell, writing in the *New York Times*, described the work as 'free from disconcerting tricks of overstatement, evasion and palimpsest', typified by 'compositions featuring highly-contrasted light and dark masses'. Jewell admired her 'healthy affection in [*sic*] subject matter as such – an affection that many modern artists have pretended was unworthy of them' and picked out her portraits of Charlie Chaplin, Gene Tunney, Claire Luce, Man Ray and Selena Royale for praise.[15]

Claire Luce was starring with Fred Astaire on Broadway in *The Gay Divorce*. Lee's half-page glamour portrait of her had just appeared in the December *Vanity Fair*. The photographs were offered for sale at $15 each but, as with Levy's other photographic shows, there were few sales. Luckily, Levy kept the unsold photographs from his exhibitions until their true aesthetic – and monetary – value was recognized forty years later. In January 1933 Levy also placed four of Lee's portraits – of Eden Gray, Renée Hubbell, Mrs Donald Friede (who appears with her husband in Pl.82) and Claire Luce – in Bergdorf Goodman's *Exhibit of New York Beauty*. Fellow exhibitors included Cecil Beaton, Arnold Genthe, Horst, Man Ray, Edward Steichen, Edward Weston and another lively female contemporary – Toni Frissell of *Vogue*. The tirelessly enthusiastic and entrepreneurial Levy also promoted Lee in another context. He organized the US première of *The Blood of a Poet* at the New York Film Society in May 1933. The film had a two-month run that autumn at the Fifth Avenue Playhouse. The programme stated that Lee had provided the inspiration for its director, and a selection of her photographs hung in the foyer.[16]

Levy introduced her to one of his most distinguished artists, Joseph Cornell (1903–72), a show of whose work preceded Lee's at the gallery. She was inspired by Cornell and his Surrealist objects to make one of the best portraits of her New York period. She photographed him with one of his earliest objects, a toy yacht topped by a butterfly, from whose mast floats a mane of blonde hair (Pl.84). As Carolyn Burke has written, 'Lee posed Cornell with the ship and turned his profile so that the blonde mane cascading from the mast becomes his own.'[17] This doubleness of gender informs Cornell's remarkable portrait of Lee. Cornell cut her head from one of the Hoyningen-Huené Lanvin fashion photographs published in the 1 October 1932 issue of American *Vogue* and later used it as the basis of a collage in which Lee's head appears twice, side by side, superimposed on both male and female Victorian clothing (Pl.86). Lee also photographed a curious and disquieting Cornell sculpture, reminiscent of the Man Ray portrait of Tanja Ramm, in which a baby's head is enclosed by a bell-jar (Pl.85).

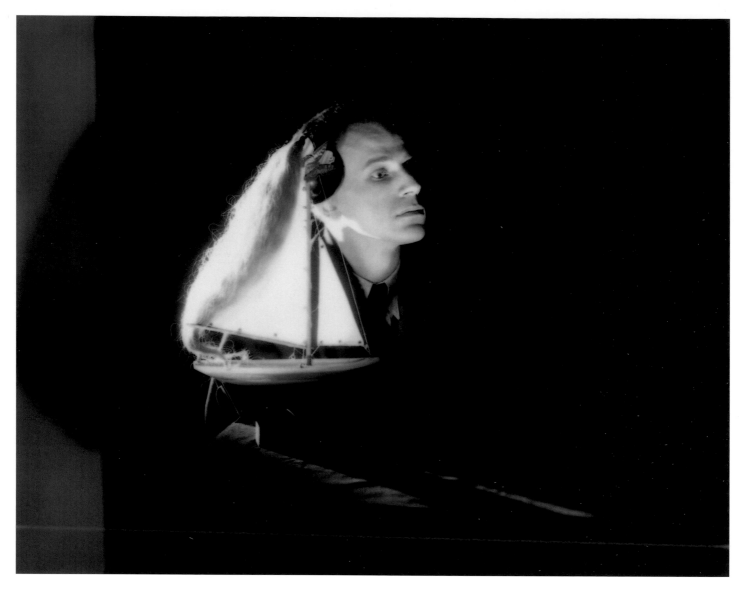

84
Joseph Cornell
1933

Sometimes, as with Lee's portrait of Gertrude ('Gertie') Lawrence, Noel Coward's partner in light comedy and musicals, it seems as if she was trying too hard (Pl. 87). There are multiple props and special lighting on the singer's left hand (while the right hand rests, claw-like, on a chair-rail). The orchestration of props and lighting suggests that Lee emulated Edward Steichen's lighting technique in her New York phase. Proof prints of this and other New York studio photographs preserved in the Lee Miller Archives, however, show that she also continued with Man Ray's typical procedures – cropping and reorientating the image in the darkroom. It is true that art directors contributed their share of cropping too. The fashion study *Woman with Furs* (Pl. 88) illuminates the subject from both sides to highlight the furs but leaves a formally distracting slice of chair visible at the right. As with the Hoyningen-Huené photograph of Lee in the Yrande sail-cloth trousers (see Pl. 10), this photograph was tightly cropped when it was published. It appeared in *Vogue* on 1 March 1933 in a feature not on furs but hair. The model, Harriett Hoctor, ballerina

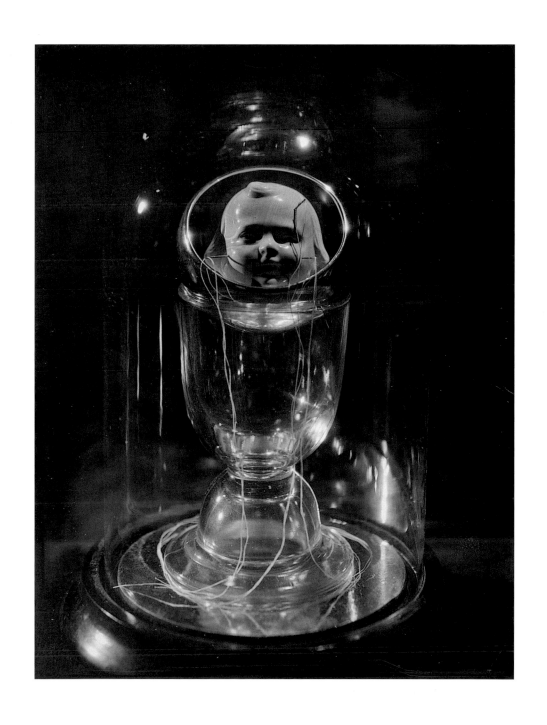

85
Object by Joseph Cornell
1933

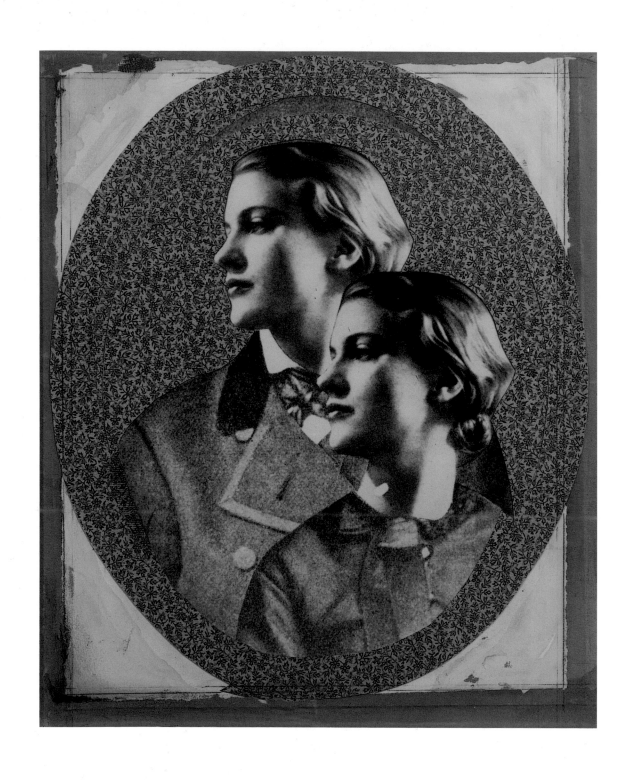

86

Joseph Cornell *Untitled* (collage of Lee Miller)

*c.*1949

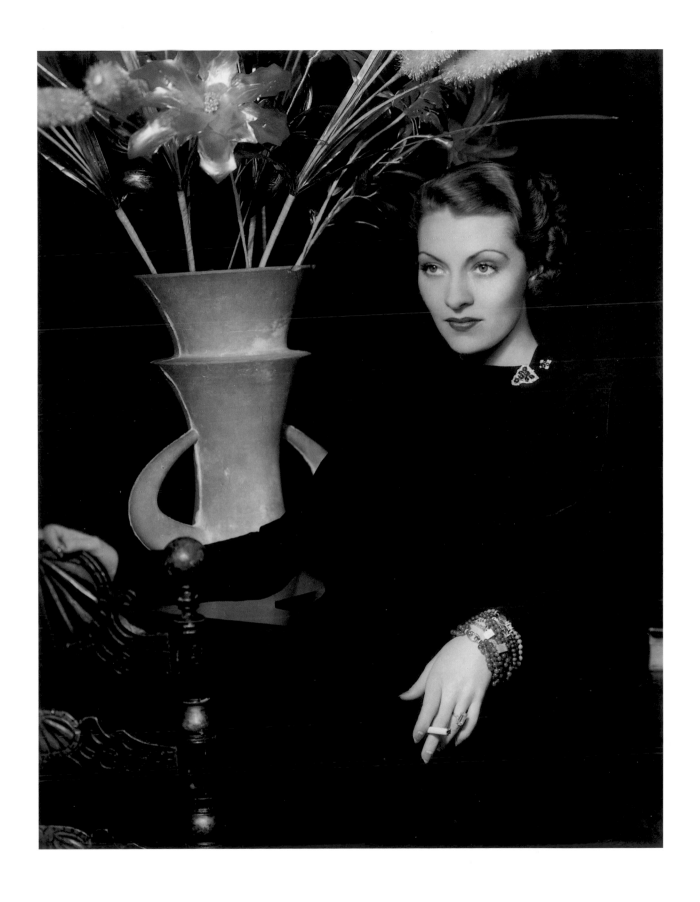

87

Gertrude Lawrence

1933

88
Untitled [Woman with Furs]
1933

and former star of the Follies, is shown wearing 'a beautiful blond transformation – which you could not tell, for the life of you, from her own hair. It is cut short in back, with little ringlets all round the neck-line. Her cape of brown blistered satin, edged with dyed blue fox, is from H. Jaeckel and Sons.' The all-important 'transformation' was credited to Manuel of Madison Avenue.

The most accomplished of Lee's New York fashion pictures is one for which she herself posed. It is fitting that Lee's finale as a model in *Vogue* should be in a virtuoso photograph from her own studio (Pl. 73). The occasion for the photograph was the same article on hair for which Lee had photographed Harriett Hoctor (and another model, Shevlin Smith). The composition is linked by

the curls of the coiffure, the ruching of the velvet gown and the ribbed upholstery of the chair in which the model sits. The lighting accentuates the head and captures the sheen of the hairband. Perhaps a Hoyningen-Huené or a Steichen would have avoided one or two small blemishes, such as the wedge of highlight on the neck, the finger of shadow on the chair and two indeterminate patches of mid-tone at the lower right (although all of these problems could easily have been addressed as part of the reproduction process). In fact, *Vogue* used a variant print in which these blemishes have been resolved and in which Lee's head is bent slightly downward to give a clearer view of the coiffure and bandeau (Pl. 89). The caption drew attention to the hairband as 'a sort of Louisa M. Alcott idea gone smart': 'The tortoise-shell like hoop that is clasped around Miss Lee Miller's head can be bought at Bendel's for not too high a price, and it is the kind that you see on several smart heads around Town, in some incredible way becoming to a great variety of faces.'

This must have been a demanding session, featuring elaborate hairdressing, the velvet wrap (from Milgrim), the stylish armchair (Westport Antique Shops), a complex lighting plan, and – presumably – Erik behind the camera. The credit must have been appealing to Lee and perhaps it is unique. *Vogue* credited the photographer – LEE MILLER – and the model: MISS LEE MILLER (COIFFURE BY DIMITRY).

Technical problems always interested Lee. She became friends with Dr Walter 'Nobby' Clark, head of research at Eastman Kodak, who introduced her to three-colour photography. She and

89
Miss Lee Miller (Coiffure by Dimitry)
Vogue, New York, 1 March 1933

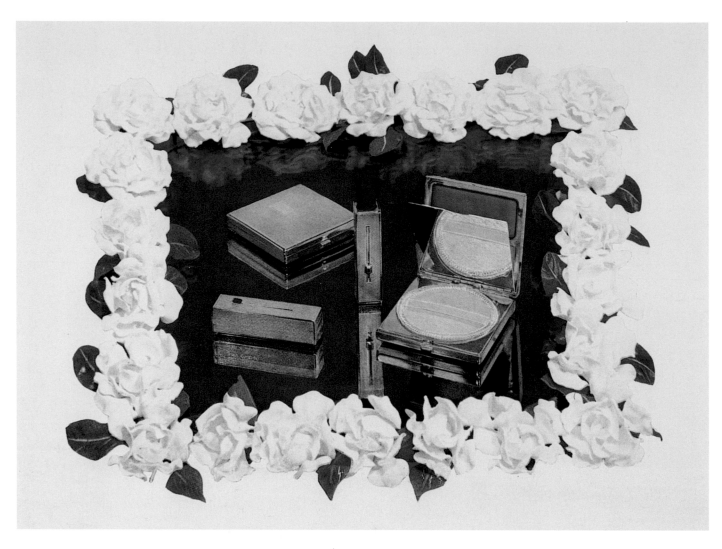

90
Cosmetics in Colour
proof of Tri-Carbro colour photograph, 1933–4

Erik made use of the technique, which required three separation negatives, for a cosmetics ad. This involved making three separate exposures of the subject on black-and-white film, each using a different colour filter (yellow, red and blue). They used an 8 × 10 inch format camera. The packaging was placed on a mirrored surface (as in Pl. 80) and surrounded by gardenias. These caused the problem as, in the era before strobe lights, the intense heat from the studio lights quickly wilted the tips of the leaves and the petals – shifting the flowers out of register between exposures. Antony Penrose recorded Erik Miller's recollections of the session:

Fortunately we did not have an art director there. If we did we would still be trying it now. We were on our own, and this was the kind of thing where Lee would really buckle down. Lee could be intolerably lazy when she wanted, but when the chips were down, she just would not quit. We worked for almost twenty-four hours straight, hardly stopping to eat or go to the john. We ended up rushing the gardenias straight from the refrigerator, spraying them and then gently placing them on the mirror so that there would not be any

water spots. The film would be all ready, so we would hit the lights, make the first exposure, then bing, bing, change the film and the filter for the second and third time. Well, finally we did it, and it was a very, very successful picture.[18]

Proofs of the different separations are preserved in the Lee Miller Archives, together with one of the finale, in which the three plates were printed consecutively (Pl. 90).

Perhaps the most interesting project in the life of Lee's New York studio was her work on the world première of Virgil Thomson and Gertrude Stein's opera *Four Saints in Three Acts*. The event was underwritten financially by the Friends and Enemies of Modern Music, whose principal angels were Kirk and Constance Askew; they also supported the New York Film Society and the Museum of Modern Art. Other great and good supporters of the event included the museum's founding director, Alfred H. Barr Jr, whom Lee was later to photograph in unlikely circumstances (see Pl. 177). As official photographer to the production, Lee photographed the composer, the

91

Virgil Thomson

1933

92
John Houseman
1933

93
Frederick Ashton
1933

94
Bertha Fitzhugh Baker,
St Settlement in Four Saints in
Three Acts
1933

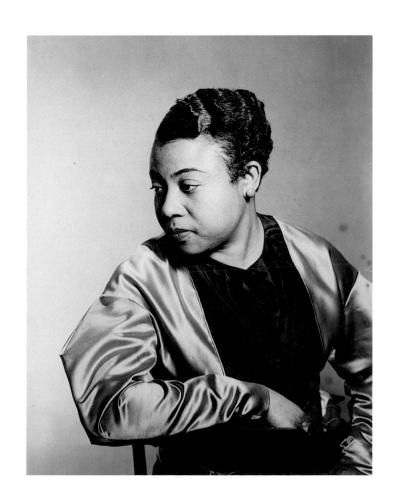

95
Eva Jessye, Choir Mistress,
Four Saints in Three Acts
1933

director (John Houseman) the choreographer (Frederick Ashton) and members of the cast (Pls 91–5). One of the many innovations offered by the opera, aside from its libretto and score, was the all-black cast. 'Since Thomson believed that American blacks would embody the opera's spirituality', Carolyn Burke points out, 'Houseman ... engaged the best singers and dancers in Harlem ... Thomson and Houseman found their singers through Eva Jessye, a classically-trained teacher and choir director.'[19] It was a major breakthrough in terms of the roles black singers and dancers were expected to perform. 'Up until that time', Jessye remarked, 'the only opportunities involved things like "Sewanee River", or "That's Why Darkies Are Born", or "Old Black Joe".'[20] Fourteen photographs by Lee of the production team and cast were published in the programme, a rare copy of which is held in the Royal Opera House Archive. The opening venue was the Wadsworth Athenaeum in Hartford, Connecticut, where the première was held on 8 February 1933. Alongside it, underlining the librettist's connections with avant-garde Paris, a major Picasso show hung in the Athenaeum's galleries. The opera was enthusiastically received and, reopening on Broadway on 20 February, became the hit of the season and ran for sixty performances. This was not only the longest run for any American opera, but surely provided the inspiration for George Gershwin's *Porgy and Bess* (1935), on which Eva Jessye worked as choral director. As Constance Askew later recalled, *Four Saints in Three Acts* 'does stand for the best part of our lives'.[21]

The opera also stands out as one of the best parts of the life of Lee Miller Studios – but it was close to being its finale. Although in May 1934 *Vanity Fair* named Lee one of the seven 'most distinguished photographers', alongside friends and rivals like Beaton, Genthe, Huené and Muray, she had lost heart for the disciplines of running a professional studio and fulfilling commissions. Or was it that she had lost her heart to Aziz Eloui Bey, whom she had met in Paris and again in St Moritz in 1931–2? He arrived in New York in June 1934, and they were married in Manhattan the following month. Lee Miller Studios closed and Lee set sail from New York, *en route* to Cairo, on 1 September.

Aside from her sympathetic photographs of Joseph Cornell and his work, Lee Miller the Surrealist seems to emerge in only one remarkable photograph from the New York period (Pl. 96). The photograph is not signed or stamped. It is inscribed on the back with the title *'Condom'* (in inverted commas) and Lee Miller's name in a hand which, Antony Penrose feels – mainly from the loop in the *L* and the shape of the *r* – fairly sure is his mother's. The photograph, on a somewhat glossy paper that is more like those used in New York than the 'eggshell' papers of the Parisian period, is unmounted and somewhat scratched. It is now in the Buhl Collection in New York. Henry Buhl acquired it from the Howard Greenberg Gallery in New York, who in turn bought it from the Los Angeles dealer G. Ray Hawkins who bought it as one of two lots consigned to Christie's, New York, as 'Property of a Private European Collector' in 1990.[22] If it is not by Lee, it is hard to imagine which other photographer could have been the author of this startling photographic puzzle.

Perhaps, Penrose suggests, it was made as a joke and not intended for publication or exhibition. Alternatively, as a speculation at very long odds, could it have been intended as the basis of that 'Surrealist jig-saw puzzle' Lee wanted to produce, as *Creative Art* reported in May 1933? Another possibility is that with this bizarre and provocative image Lee was sticking up two fingers to what she had come to regard as the sterile world of commercial photography.

96
Condom
*c.*1934?

4 Egypt 1934–39

From the Top of the Great Pyramid
*c.*1937

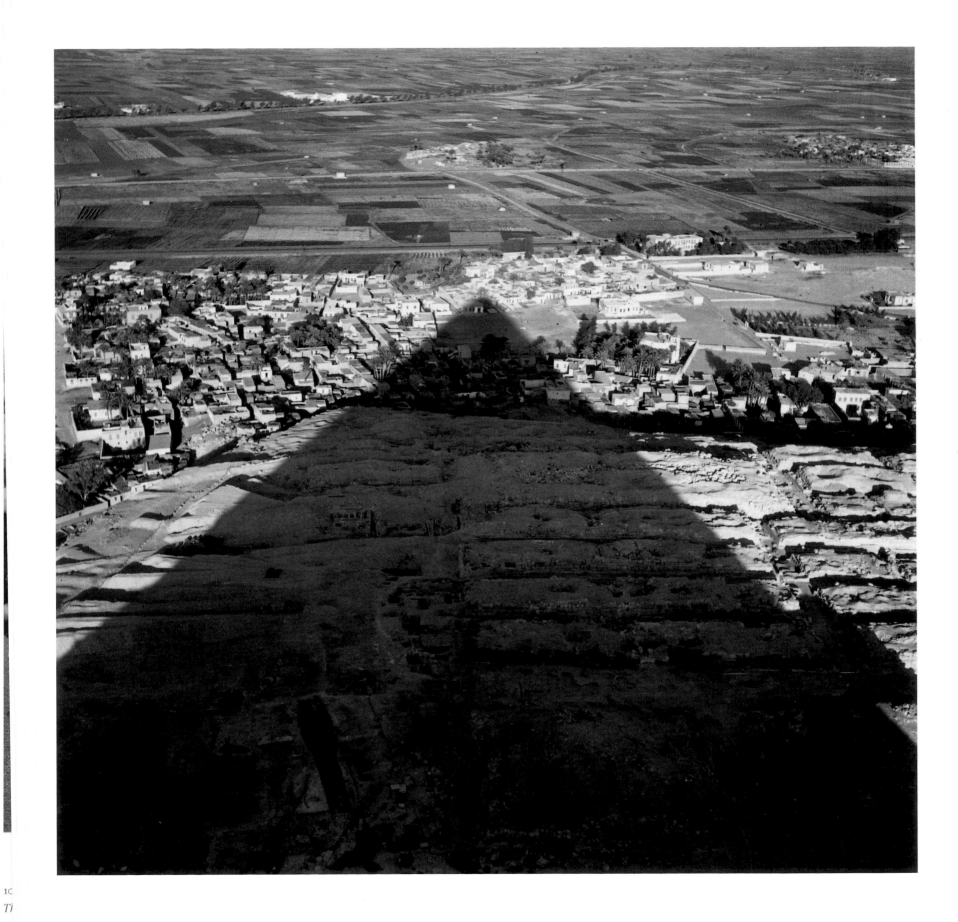

109

Untitled [Snail Shells]

*c.*1936

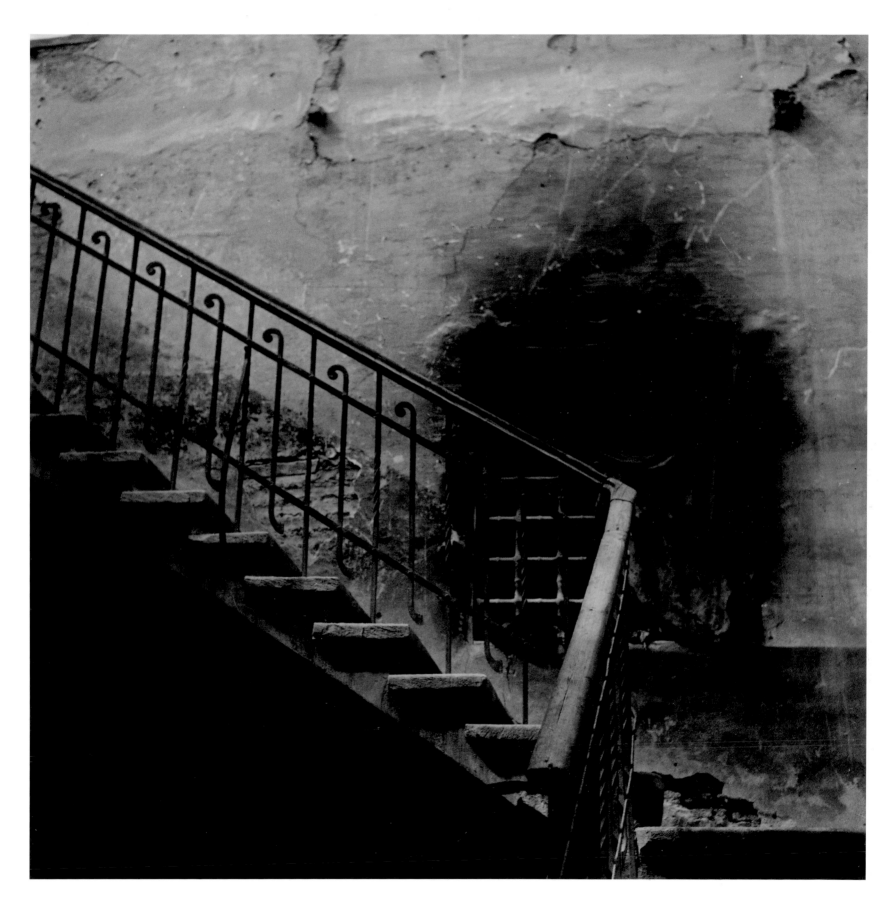

110
Untitled [Stairway]
*c.*1936

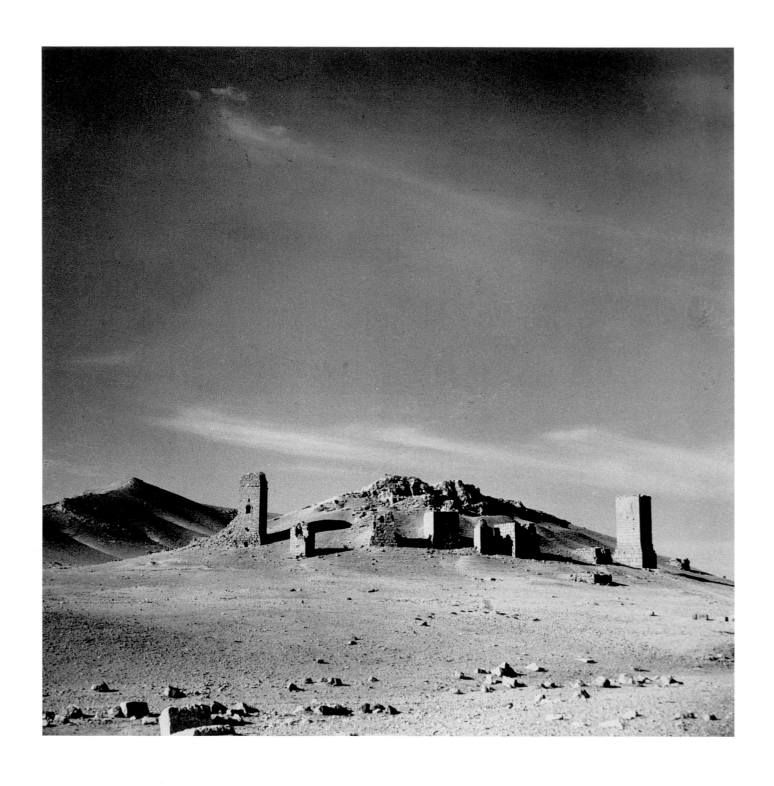

111

Castle Ruins

c.1936

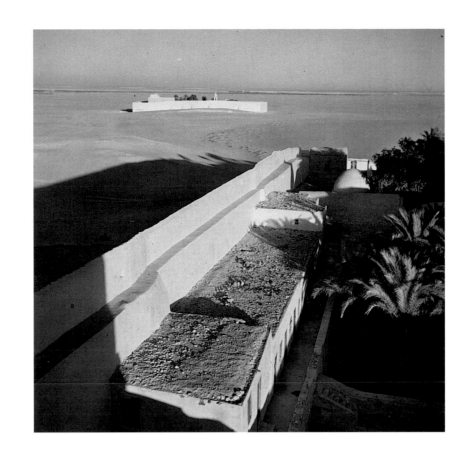

112
*The Monasteries of Deir Simon
and Deir Barnabas*
Sinai Peninsula, *c*.1936

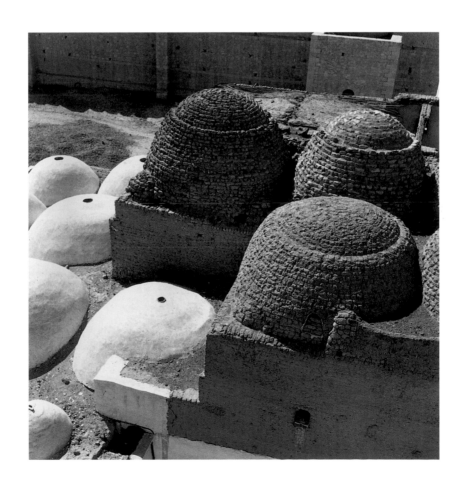

113
Domed roofs
Wadi Natrun, *c*.1936

114

Monastery of Wadi Natrun: Doorway

c.1936

115
Restoration of Roman Ruins
El Kharga, *c.*1936

116
The Native, also known as Cock Rock
Western Desert, 1939

126

Picnic: Nusch and Paul Eluard, Roland Penrose, Man Ray, and Ady Fidelin
Île Sainte-Marguerite, Cannes, France, 1937

142

127
Dora Maar
Mougins, 1937

Nougé found for the picture and which explains the bringing together of external nature with internal consciousness, the kiss bestowed by the mind on the unconscious of nature and the imprint that it leaves.'[22] It is surely remarkable that this poetic description of the painting applies equally well to the photograph that inspired it.

Most of the Cornwall party reconvened to continue their proto-hippy love-in at Mougins in the south of France, where Picasso was on holiday. Lee captured the mood of her high-spirited friends in a photograph of a picnic near Cannes (Pl.126). In Mougins, Lee, who was painted six times by Picasso as 'L'Arlésienne', photographed his companion Dora Maar (Pl.127) and made her first collage (see Pl.1). This includes a postcard illustrating a bird's eye view of Menton. It was at Mougins that Penrose began using postcards in his collages for the first time. Perhaps part of the attraction was the Surrealist nature of their heightened and artificial-looking colour. Lee flipped the card of Menton from its landscape format towards the vertical, emphasizing the series of finger-like headlands poking into the Mediterranean. These shapes, reminiscent of the towers of Gaudí's Sagrada Familia in Barcelona, are echoed by a piece of rust-coloured paper printed by the decalcomania technique, which Penrose picked up from Max Ernst, its major exponent. (Decalcomania involves squeezing moist pigment between two sheets of paper, the results being determined by chance.) Next to this is a fragment of a photograph that was probably taken in

137
Indecent Exposure, 'Please take me away...'
London, 1940

138
War and Peace in a London Park
London, 1940

efficiency. However, she was sometimes asked for, or proposed herself, more ambitious set pieces. In February 1942 'Model Posture' was 'pondered and posed by Iris Lockwood, who stood badly for the photograph on right... to show the shocking effect on clothes and figure'. Lockwood, a regular Brogue model who was then appearing on the West End stage in *Get a Load of This*, posed properly in the Fortnum and Mason dress and Erik hat at the left – both times montaged into bubbles over which she looms goddess-like (Pl. 139). This is a reprise – made even more dramatic and complex – of an idea Hoyningen-Huené had carried out ten years before, in August 1932, for Paris *Vogue*. Unlike Huené's montage, however, it is now a woman's face that looms over the encapsulated models. In the same issue, for a feature titled 'Make the Most of Your Face', Lee montaged four solarized portraits of women on to a page, signing it with a flourish 'lee miller 1942'. 'Warwork', ran the caption, 'whether in the services or factories, has brought a wave of shorter hair – for neatness, easy cleanliness and good looks. The busy women opposite all say it's easier, prove it's attractive.' The glamorous heads included those of the actresses Deborah Kerr and Coral Browne and of Brogue's features editor, Lesley Blanch, a lively writer who collaborated on stories with Lee.

From 1942 onwards Lee's photographs were often laid out by a young art director named Alex Kroll. He shared the duties with John Parsons, designing alternate issues of the magazine. Kroll had studied at the Reimann School in London. His teachers included the painter Leonard Rosoman, the typographer Robert Harling and the Bauhaus-trained designer Elsa Taterka. Kroll recalls that there was 'a whiff of the Bauhaus' about the Reimann School. His contributions to the pages of Brogue were elegantly cosmopolitan – lucid, powerful and imaginative presentations of word, image and energized white space. He and Parsons worked with the Bodoni Book font. Printed sheets of this were available, ready to be cut out and pasted down on layout sheets. Batches of photographs reached the designers from the studio already marked with their preferences by the photographer, the editor responsible for the story and the editor of the magazine, Audrey Withers. Photographs were rescaled on a Photostat machine and added to the layout pages to be sent to the printers. Covers were often provided by the New York office, arriving in the form of printing plates. John Rawlings had returned to New York by 1942, but his photographs continued to be seen in Brogue alongside other pictures sent from New York by Horst, Toni Frissell and others. The staff was small: the editor, fashion editor, features editor and society editor, each with minimal help, a production man, a retoucher, and a girl who pasted up the layouts. This small team created some of the most remarkable writing, photography and magazine design of the Second World War.[8]

In June 1943 Brogue published a different kind of set piece by Lee – 'Night Life Now', about an ATS (Women's Auxiliary Territorial Service) searchlight crew. This involved not only a startling opening full page of the searchlight dramatically silhouetting two of the female crew in its beam, but also a double-page spread in which a further eight photographs emerge as vignettes from the black pages, which are slashed by a raking diagonal beam of light (Pls 140, 141). 'Night Life Now' looks like a photo-essay more suitable for *Life* than for Brogue. In fact, Lee worked on it with David E. Scherman (1916–97), a *Life* photographer who had joined the magazine's London office in 1941. He joined the Downshire Hill household in a *ménage à trois* in 1942 and became Lee's lover and photographic buddy for the rest of the war. Her portrait of Scherman from 1943 is one of her more remarkable war photographs (Pl. 142). It has been well analysed by Karen A. Levine:

139
'Good and Bad Posture'
Vogue, London, February 1942

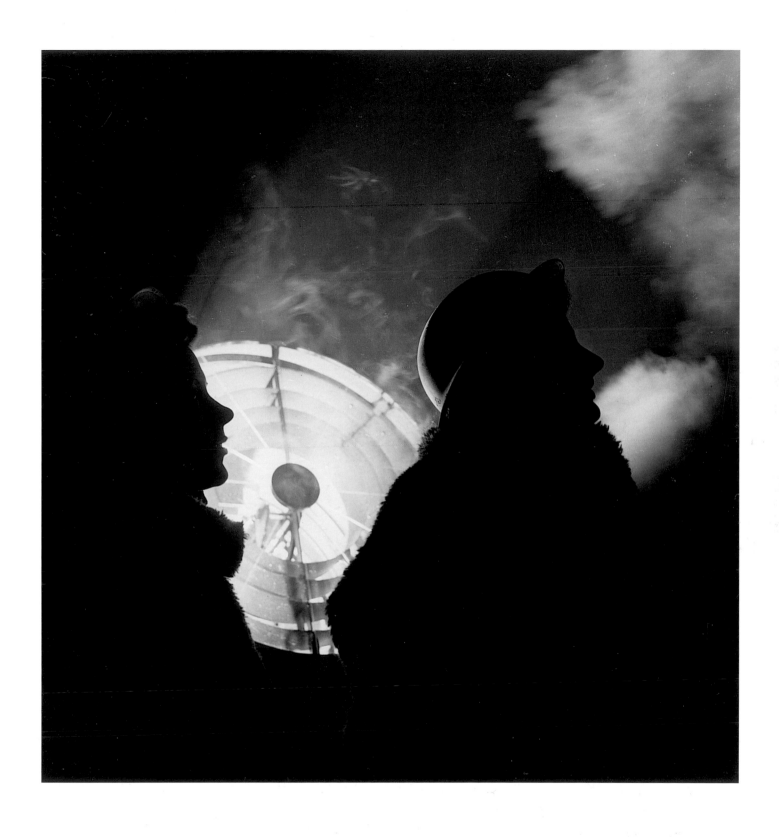

140

'Night Life Now': ATS Searchlight Crew

Vogue, London, June 1943

NIGHT LIFE NOW
(continued)

Emergency field kitchen W.A.A.F.

The balloon is bedded down

Maintenance W.R.N.S. on the job

LEE MILLER PHOTOGRAPHS

W.R.N.S. boat crew coming ashore

141
'Night Life Now': ATS Searchlight Crew
Vogue, London, June 1943

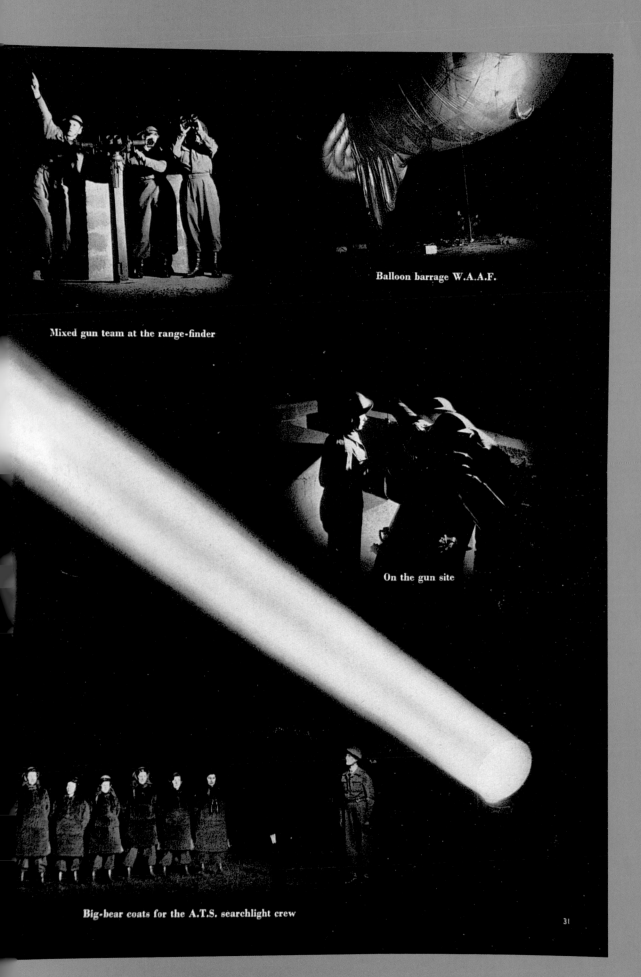

Balloon barrage W.A.A.F.

Mixed gun team at the range-finder

On the gun site

Big-bear coats for the A.T.S. searchlight crew

Photographer David E. Scherman Equipped for the War in Europe, London... depicts
Scherman posing beside his tripod-raised camera, clad in a gasmask and flak helmet
and sheltered by a large umbrella. The image is brilliantly composed – not only does
Scherman's helmet brim mimic the curve of the umbrella above, but most importantly the
mask's circular eye coverings echo the diameter and glass-and-metal sheen of the camera
lens. Scherman's camera is as central a part of his 'uniform' as is a soldier's gas mask or
gun. It is his weapon – when faced with frontline drama or danger he will shoot – but it
cannot protect him. With the helmet and gas mask, Miller implies that photographers
are vulnerable to the same dangers as the troops; they must be willing to risk their lives
to document the war. But by allowing the gaily striped umbrella to dominate the
composition, Miller presents this risky proposition as a bit of a lark. Within this context,
Scherman's tailored overcoat and elegant wristwatch may also be significant.[9]

As we shall see, Lee herself went to war accoutred with similar nonchalance. She was far from
relaxed, however, about her credit for 'Night Life Now', especially when it was rerun in American
Vogue. She wrote to her editor, Audrey Withers:

> Saw the 'Night Life' spread in N.Y. *Vogue* and I think I might have had more than the
> usual hidden signature – after all it was me who (a) thought it up (b) stayed up all nite
> for a month doing it (c) didn't kick up when my London credit was so small (d) would
> appreciate the N.Y. office knowing that their little War Correspondent *did* a story – on
> acc't of what they might even like to assign a few similar jobs.[10]

It was Scherman who advised Lee that she was eligible, as an American citizen, to apply to
become an official US Army War Correspondent. With the support of Audrey Withers, Lee's
accreditation as correspondent for UK *Vogue* arrived in December 1942. This gave her not only a
uniform, swiftly ordered from a Savile Row tailor, and access to the PX stores provided for
American military and diplomatic personnel, but – much more significant – access to US military
transport for herself and her film to, from and within the theatre of war, plus accommodation and
essential supplies (Pl. 143).

Lee continued, however, to photograph on the Home Front. There were other important
landmarks in her early career at Brogue. She covered the London Collections for the first time in
March 1941. Her first colour photograph, *Checkmate*, a fashion photograph of an overcoat,
appeared in October 1943, followed by others in later issues. Until this time colour had been the
preserve of John Rawlings, one of its best early masters, with contributions from the New York
studio by Horst and others. Lee's first colour cover for Brogue appeared in April 1944. It was an
elegant, jaunty shot of a model wearing a 'Valstar' oiled cotton raincoat, welcoming spring with the
props of a yellow umbrella from Selfridges, a spray of daffodils and the sunshine of Lee's adroitly
managed floodlights in *Brogue*'s studio. It is interesting that both this and a later colour cover by
Lee (June 1944) are reproduced inside the magazine as black-and-white insets with a credit to her.
Other covers were not credited in this way, which suggests that Lee – keen to ensure recognition of
her latest progress – talked the editor into doing it.

142
Life *Photographer David E. Scherman Equipped for War*
1942

superlative technical knowledge, great accuracy and a ruthless persistence in achieving her objectives'. Lee is likely to have enjoyed meeting and then reading about this glamorous woman photographer, who had made a first career photographing cars for advertising but found it too 'static' – not to say soul-destroying – 'tore up all her contracts' and moved successfully into industrial photography and then reportage. She was, furthermore, a woman whose 'resources for amusement and relaxation lie in her ability to play games'. Lee could have learned a great deal about the lighting equipment as well as cameras, required by the successful photographer-reporter.

As it happens, the same issue of the magazine, January 1943, carried a fashion photograph by Lee that demonstrated her complete control over her craft as a fashion photographer (Pl.144). It is a kind of fashion-on-location image that only the draughtsmen could have hoped to capture during Lee's own career as a model. The photograph is titled *Cover Coats* and the caption runs:

> Here are two girls who know enough to go out into the rain without getting wet. The raincoat on the left is rubber-backed cotton, striped navy and red, with a red-lined hood (Simpson's). On the right is one of Wetherall's Rufstuf raincoats of rubber-backed hessian, several colours (and hat, at Wetherall shops). Overboots at Lillywhite's.

The girls, possibly young actresses like other Brogue models, have taken up convincing poses – both natural-seeming and nonchalantly elegant – on a rainy day beside a large poster; its punctuation makes the nearer girl into a Spanish exclamation mark. The poses seem fitting for young women wearing new clothes in a public space, perhaps waiting for friends. The poses are remarkably natural for the period, looking forward to the casual chic of the 1960s. It appears that Lee brightened the scene by carefully adjusting exposure and development, rather than by flash. The result is highly effective tonally, emphasizing the beauty of the models' faces, capturing their gestures and fully expressing the garments, while also recording glistening paving stones, misty atmosphere and the occasional exhilaration of showery weather.

Such was Lee's role at Brogue that by spring 1944 she was not only a highly versatile and skilled operator but also by a long stretch the magazine's most prolific photographic contributor. Thus, in April 1944, Lee provided the following: a colour cover and the superb *Cover Coats* photograph; five photographs for a story on 'Private Practice'; two portraits, including one of the dynamic, short-lived photographer, poet, painter and film-maker Humphrey Jennings – a variant of the fine vintage print published here (Pl.145); further fashion stories on 'Rayon – the Stuff of Summer' (five photographs) and 'New Clothes for Old' (two photographs). In the issue for May 1944 the photographs were distributed like this among the *Vogue* staff: Rawlings two, Haupt (*Vogue* Studio) two, Parkinson three, Beaton five, Lee fourteen black-and-white and eight colour. In June 1944 Lee provided another colour cover and twenty-one photographs inside. Her work dominated the next two issues, but another landmark occurred in August 1944, which carried 'Citizens of the World: Ed Murrow – Photograph and text by Lee Miller' (Pl.146). It was this feature that gave Lee her real start in written journalism – but, of course, 'gave' is not the right word. According to Antony Penrose, Lee badgered Audrey Withers into assigning her the text. Her notes and drafts for the piece survive, as does her agonized covering letter to Withers:

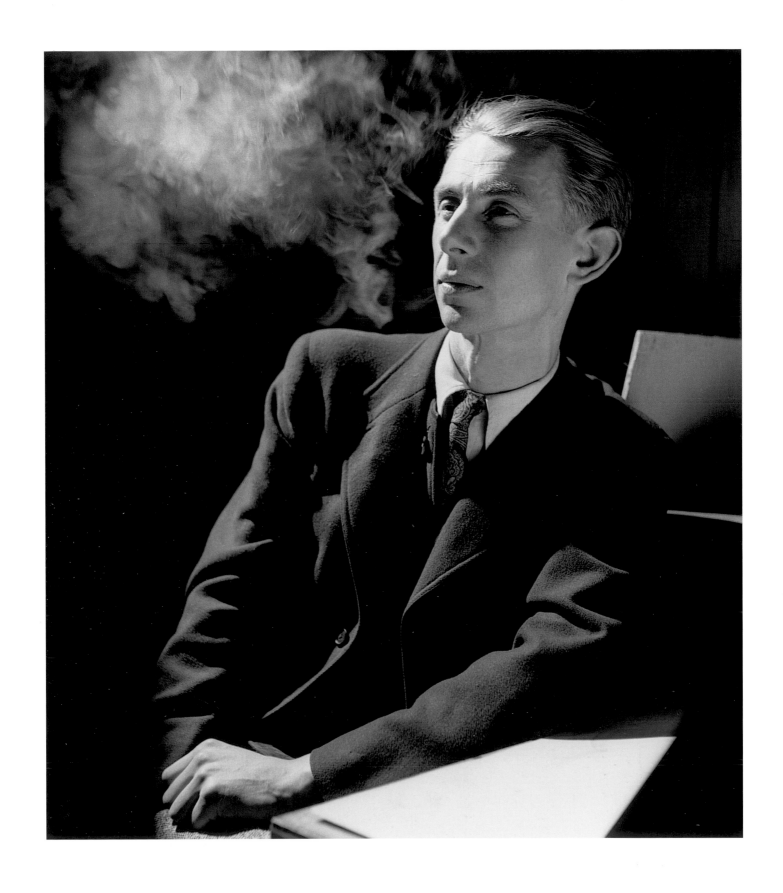

145
Humphrey Jennings
London, 1944

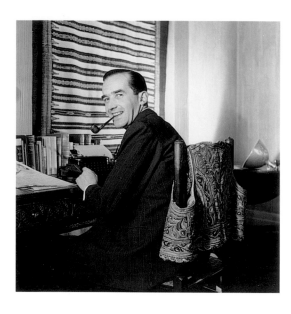

146
'Citizens of the World – Ed Murrow'
Vogue, London, August 1944

Dear Audrey

This was all a big mistake – after all, I've spent fifteen or so years of my life learning how to take a picture – you know, the thing that is worth ten thousand words, and here I am cutting my own throat and imitating these people, writers who I've been pretending are *démodé*.

My surprise and grief is not that I find words a technique all alone – I already knew this but that I should have been naïve and idiotic enough to accept such an assignment, and have the temerity to attack it in the face of knowing better has subjected me to many hours of frustration over written organisation of the facts and ideas I had the luck to have handed to me on a platter by Ed Murrow.

I will hereby append what I have written, and also what other notes I have. I abandon them to your mercy – a disagreeable task for a writer, to put together someone else's interview with someone else... but I am afraid that it will not now be possible for anyone else to catch hold of Ed or Janet [his wife]... I've buggered all our sources. As I've already used up all the time and trouble they could decently be asked to spare... even if they had large quantities of vanity.

Love, Lee [11]

Withers published Lee's final draft as it stood. Here is the exemplary opening paragraph, in which Lee has to address the problem of introducing a legend to readers who are unlikely to have heard him – as Murrow broadcast from Britain to audiences back in the US – but had probably heard of him. The paragraph uses arresting newfangled phrases like 'cable-quoted' (i.e. quoted in the form of transcripts transmitted by electric cable, like telegram), skilful wordplay ('A radio prophet is a man without face in his own country') and, once more, the Brogue 'we':

Very few people in England have heard Ed Murrow: but we know him, like him, and respect him. He is a star in our journalistic constellation. He is constantly quoted and referred to by people who know people who have short-wave sets, and he is cable-quoted

back from New York to the Press here as an authority. A radio prophet is a man without face in his own country. Here he is without voice, like the Mermaid in Hans Christian Andersen's fairy tale.

The article shows how Lee's photographic training played into the vivid observation typical of her prose style:

Ed Murrow is literally tall, dark and handsome. In a Press comment on his winning of the Peabody prize he was also described as saturnine and elegant. Elegant, yes – he wears very good clothes with very good style, whether it's pin-stripe lounge suit, army uniform, or the open-necked shirt and tweed jacket I saw him broadcast in. Saturnine, no – he doesn't laugh much and he doesn't interrupt people with wisecracks, but I've watched him smile. It starts at the back of his neck and creeps up over his scalp until first his eyes smile and then his mouth, and there's nothing sluggish or gloomy about that.

Murrow tapped out random thoughts on the typewriter as Lee prepared for the shot, and she later received the sheet of paper as a memento. Among the stream of consciousness thoughts Murrow typed is this: 'When Lee comes to take pictures she also straightens out the wiring... must ask her if she bought her pliers...'[12]

'Where is fashion going?' Brogue asked a panel of experts in September 1944. Lee's answer came in the form of her first war reportage, 'Unarmed Warriors', an essay about front-line nursing in the aftermath of the Normandy landings. The essay was illustrated by twelve photographs and a portrait of Lee in uniform, wearing a steel helmet. This was equipped with an adjustable visor and painted with eye-slits to give it the – somewhat Surrealist – likeness of a helmet from the age of chivalry (Pl.147). The photographer/author was heralded in these terms: 'Lee Miller of Vogue's staff, first woman photographer to visit Normandy, brought back these pictures, this account of medical wonders behind the battle front.' A full-page lead picture showed a field hospital at night, captioned with words from Lee's dispatch: 'contrast of white towels, concentrated light and deep shadows...'. The layout ensures maximum impact for the photo-essay, the lead picture taking the reader straight to the centre of the story. As with many of Don McCullin's justly celebrated photographs of the Vietnam War twenty-five years later, the importance of the photographs does not lie in the precise information they convey but in their visceral immediacy. As with McCullin, the role of the photographer as an identifiable witness, and perhaps someone also to be identified with, is important. Thus, Brogue's readers saw Lee in uniform and helmet, as later we were to see McCullin, and they read her own accompanying words as a later generation was in turn to read his. A dozen smaller photographs round out the story, showing us how *Wire 'Cats'-Cradles' Draped the Walls*, as all-important telephone communications were installed in ruined towns, or telling us starkly of *A Dying Man – but Saved by Devoted Care* (Pl.148). As with McCullin, once more, when we look at the pictures again we can recognize the intuitive eloquence of their composition (Pls 149, 150).

Lee's dispatch expertly sets the scene, taking us not only into the plane, across the channel and over France, but directly into the emotions:

As we flew into sight of France I swallowed hard on what were trying to be tears and remembered a movie actress kissing a handful of earth. My self-conscious analysis was forgotten in greedily studying the soft, grey-skied panorama of nearly a thousand square miles of France ... of freed France.

She fills in the details of the field hospital that landed on D Day plus five, whose staff of forty doctors and forty nurses had averaged a hundred operations every twenty-four hours on six operating tables, as well as caring for 400 transient patients. But the real value of the text is not only to contextualize the photographs but also to evoke experiences beyond the photographable. This is from a description of the surgical tent, where six groups of people worked around six operating tables:

Three of the patients were conscious. The far one was nearly completed; that is, his leg had been dealt with and clench-faced men were patting the last of a plaster bandage into place. In the chiaroscuro of khaki and white I was reminded of Hieronymous Bosch's painting 'The Carrying of the Cross'. He had watched me take his photograph and had made an effort with his good hand to smooth his hair. I didn't know that he was already asleep with sodium pentathol when they had started on his arm. I had turned away for fear my face would betray to him what I had seen.

Lee's photographs showed the war from the distaff side, featuring the role of the nurses and something of their daily lives. Women had nursed the wounded, diseased and dying of the Crimean War and the First World War, their service known through such emblematic figures as Florence Nightingale and Vera Brittain, but the Second World War brought this difference: now the women's contribution was being photographed as it took place, by a woman, and published almost at once.

Lee must have seemed like superwoman to her readers, as her first, very long, dispatch from France was followed in the same issue by 'Reflections of Personality' – a story on hat fashions featuring the ballerina Margot Fonteyn and the actress Anne Todd (three photographs), 'A Suit that Works 18 Hours a Day – A Dress that Works 7 Days a Week' (eight photographs), and 'Scottish Hospitality' (seven photographs).

Vogue for October 1944 brought 'Paris Regained', with pictures by 'a daring group of young French resistance photographers' but also Lee's eyewitness dispatch. She showed Paris both 'Within' and 'Without' (Pl.152). 'Within: the cultural life of Paris flourishes bravely' featured Lee's photographs of Picasso in his studio and posing with herself (Pl.151), double portraits of Paul and Nusch Eluard, Boris Kochno and Christian Bérard (who loaded rifles for Free French fighters firing from their balcony) and Michel Brunhoff, editor of Paris *Vogue* (which ceased publication during the German occupation) with Jean Pagès, formerly a *Vogue* artist and now a liaison officer. 'Without' featured 'the lovely skyline, the women's pretty looks', on which Lee expanded in her report. On the streets she saw the style that became Christian Dior's New Look the following year:

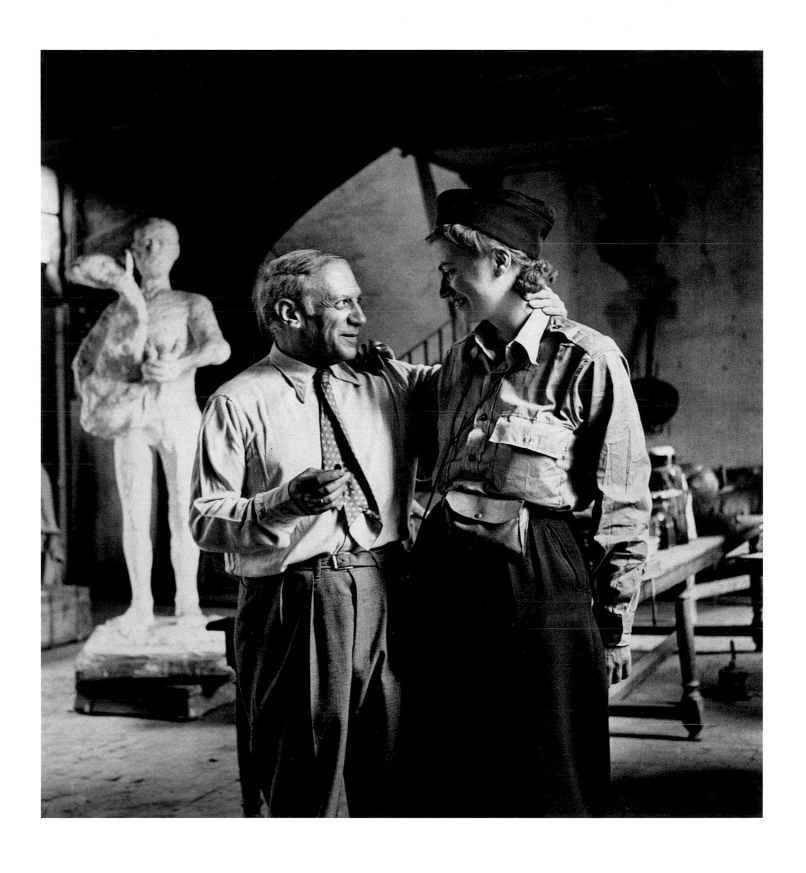

151

Lee Miller and Pablo Picasso – Liberation of Paris

1944

GERMANS ARE LIKE THIS

The German people—audacious, servile, well-fed—have forgotten that they are Nazis, that we are their enemies. Notes on Germany now...

By Lee Miller

GERMANY is a beautiful landscape dotted with jewel-like villages, blotched with ruined cities, inhabited by schizophrenics. There are blossoms and vistas, tiny pastel plaster towns, like a modern water colour of mediaeval memory. There are little girls in white dresses and garlands, children with stilts and marbles and tops and hoops; mothers sew and sweep and bake and farmers plough and harrow; all just like real people. But they aren't. They are the enemy.

The land war was not fought enough on German soil; the punishment for aggression has not yet been sufficiently severe. We thought they'd fight fiendishly, once their own land was invaded, but each house had a white flag on the Nazi banner pole and our armour thrust on, ignoring and by-passing thousands of towns which hadn't seen a soldier and will remain unimpressed by our might and our men. They are going to find the end and the loss of the war mysterious and inexplicable. The only thing they will understand of it: the casualty lists and the monumental destruction of their cities from the air.

My first few days in Cologne were full of disgusting and horrifying encounters. (Cologne edges up and sprawls across the Rhine. The Cathedral looks sourly on a dirty sea of ruin. The great bridge across the river has a broken back.) Reputedly, there were a hundred thousand people living in the vaulted basements of this shell of a city. Very few appeared; those who did were palely clean and well-nourished on the stolen and stored fats of Normandy and Belgium. They were repugnant in their servility, amiability, hypocrisy. I was constantly insulted by slimy German invitations to dine, in German underground houses, and amazed by the audacity of Germans who begged rides in military vehicles and tried to cadge cigarettes, chewing gum, soap. How dared they? Whom did they think we'd been braving flesh and eyesight against all these years? Who did they think were my friends and compatriots but the blitzed citizens of London and the ill-treated French prisoners of war? Who did they think were my flesh and blood but the American pilots and infantrymen? What kind of idiocy and stupidity blinds them to my feelings? From what kind of escape zones in the unventilated alleys of their brains are they able to conjure up the idea that they are a liberated, not a conquered people?

I'm told that it's all our fault. We claimed to be waging war on the Nazis, only. Our patience with the Germans has been so exaggeratedly correct that they think they can get away with anything. Well, perhaps they can. In the towns we have occupied, the people grin from the windows in friendly fashion. They are astonished that we don't wave, or return their smiles. Even before the surrender, the G.I.'s passed cocky young men in the streets, dressed as civilians. They were the former soldiers. And there was nothing to do about it.

I don't know why the Cologne prison is more haunting than others I've seen and smelled. In France the execution chambers, one of which was a target range for would-be sportsmen in peace time, had heaps of shot-through, worn-out posts in the back alley. So many bullets had sped through so many Frenchmen that the posts had worn out. Another had ill-concealed mass graves for men who had been used as game targets, rather like a live pigeon shoot. One had heated walls and the bloody, clawed handmarks of the roasting victims were baked like the designs on pottery. There were scraped messages of courage, defiance, and advice to the new-comer on the cell walls, and the German prisoners of war who were detailed to dig up the mutilated bodies vomited so much that they were incapable of their task.

The impressive thing about the Cologne jail is that it was in the heart of Germany. These things had been done inside the Fatherland, not by people misbehaving like tourists; nor were they the exaggerations of the licentious energy of a select few who couldn't be traced. These were not the feared SS men or the godly Elite; they were rear echelon Nazi and public government officials, quite normal. This went on in a great German city where the inhabitants must have known and acquiesced or at least suspected and ignored the activities of their lovers and spouses and sons.

There need be no committee to investigate atrocities after this war...no one can be quite fatuous enough to start secret clubs to whitewash German guilt, as they did after the last war. There are millions of witnesses and no isolated freak cases. (Continued on page 192)

160

Scales of Justice
Vogue, London, June 19

162

'Germans Are Like This'
Vogue, New York, June 1945

erman children, well-fed, healthy...burned bones of starved prisoners

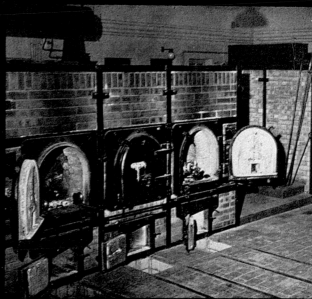

derly villages, patterned, quiet...orderly furnaces to burn bodies

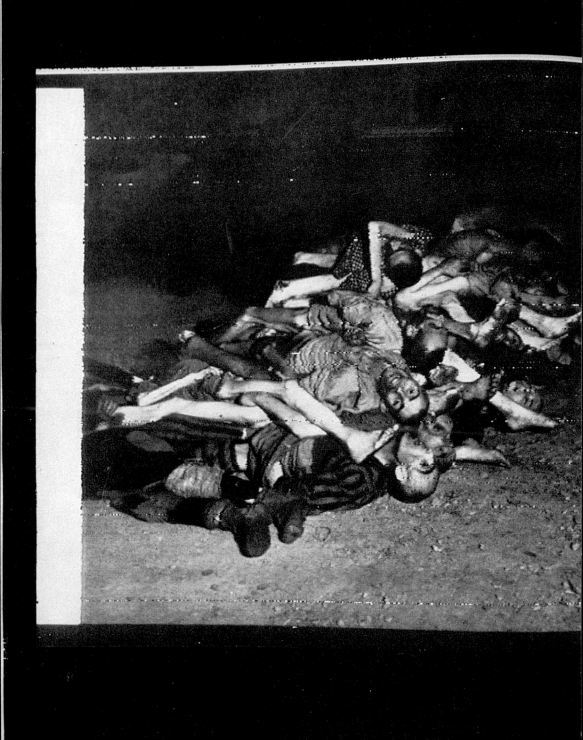

"BELIEVE IT"

Lee Miller cables from Germany

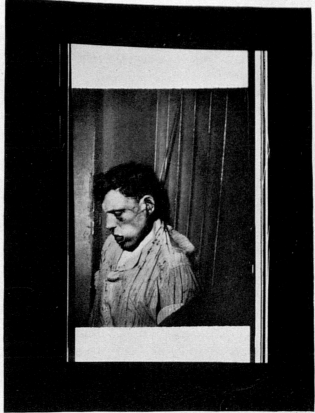

LEE MILLER

"THIS is Buchenwald Concentration Camp at Weimar." The photograph on the left shows a pile of starved bodies, the one above, a prisoner hanged on an iron hook, his face clubbed.

Lee Miller has been with American Armies almost since D-Day last June: she has seen the freeing of France, Luxembourg, Belgium, and Alsace, crossed the Rhine into Cologne, Frankfurt to Munich. Saw the Dachau prison camp. She cabled: "No question that German civilians knew what went on. Railway siding into Dachau camp runs past villas, with trains of dead and semi-dead deportees. I usually don't take pictures of horrors. But don't think that every town and every area isn't rich with them. I hope Vogue will feel that it can publish these pictures...."

Here they are.

Leipzig Burgomaster's pretty daughter, a victim of Nazi philosophy, kills self' (Pl.164). The text published in the adjacent pages does not give further details of the woman or the scene Lee witnessed in Leipzig but provides a context for the picture. Lee's major points in her article were that the mass of Germans knew what was happening in their midst and must share in the nation's guilt. She met many Germans who professed no knowledge and accepted no guilt:

> The impressive thing about the Cologne jail is that it was in the heart of Germany. These things had been done inside the Fatherland, not by people misbehaving like tourists; nor were they the exaggerations of the licentious energy of a select few who couldn't be traced. These were not the feared SS men or the godly Elite; they were rear echelon Nazi and public government officials, quite normal. This went on in a great German city where the inhabitants must have known and acquiesced or at least suspected and ignored the activities of their lovers and spouses and sons.

This is surely why Lee insisted on making perfectly lit and composed posthumous portraits of the Bürgermeister's daughter and the SS man underwater (Pl.165). Such pictures remind us of Lee's first-hand knowledge of Surrealism, the idea of 'convulsive beauty' and its many images of effigies – but there is a more direct, historical element to these photographs. Lee's dispatches describe what Hannah Arendt would term the 'banality of evil'.[16] Some of Lee's most vivid phrases are absent from the much reduced, and tightly edited, text in American *Vogue*. While Brogue decided against publishing many of Lee's most searing photographs, the magazine ran her dispatches at great length and apparently without editing them. In Brogue, for example, the report begins 'Germany is a beautiful landscape dotted with jewel-like villages, blotched with ruined cities, and inhabited by schizophrenetics', while the American version edits the last word (whether it was a typo or a conscious neologism of Lee's) to 'schizophrenics'. The British version includes such bitterly sardonic phrases as 'the Gestapo Rotary Club', which parallel Arendt's famous formulation. However, the extensive dispatch published by Brogue also omits Lee's account of the scene she witnessed in the town hall in Leipzig:

> The love of death which is the under-pattern of the German living caught up with the high officials of the regime, and they gave a great party, toasted death and Hitler and poisoned themselves. In one of the offices, a grey-haired man [Alfred Freyburg, Bürgermeister of Leipzig] sits with his head bowed on his crossed hands on the desk. Opposite him, sprawled back in a chair is a faded woman, eyes open and a trickle of blood on her chin. Leaning back on the sofa is a girl with extraordinarily pretty teeth, waxen and dusty. Her nurse's uniform is sprinkled with plaster from the battle for the city hall which raged outside after their deaths.

This was published for the first time much later by Antony Penrose in his book *Lee Miller's War* in 1988.[17]

Katharina Menzel-Ahr points out that Margaret Bourke-White photographed the same scene from above and has contrasted the views of the scene by the two photographers.[18] It seems

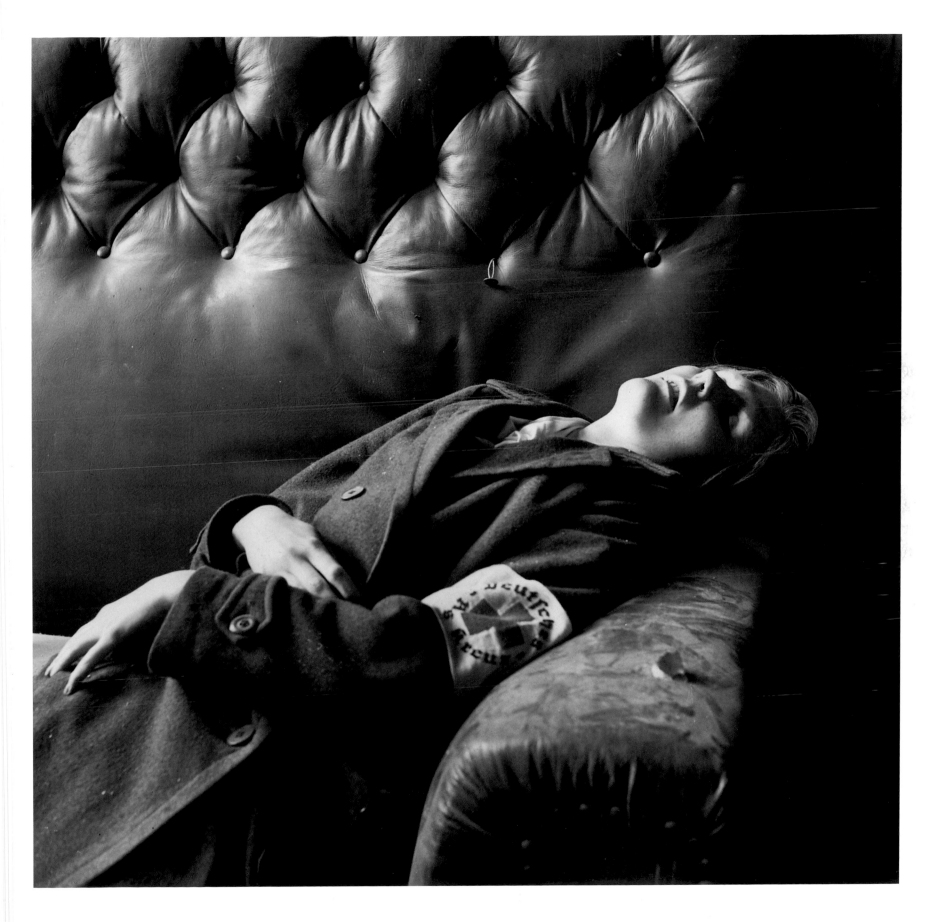

164
Bürgermeister of Leipzig's Daughter Suicided
1945

177
'Working Guests': Alfred H. Barr Jr Feeding the Pigs
Farley Farm, 1952

212

178
'Working Guests': Richard and Terri Hamilton
Farley Farm, 1951

Notes

Introduction

1 Burke, p.176
2 Lee Miller file, Photography Collection, The Art Institute of Chicago, letter of 9 October 1976
3 *Ibid.*, undated letter
4 Quoted by Burke, p.167

Chapter 1: The Art of the Model

1 Amaya, p.55
2 Burke, p.23
3 *Ibid.*, p.19; John Miller Collection, Poughkeepsie, NY
4 *Ibid.*, p.31
5 *Ibid.*, p.17
6 Antony Penrose, private communication
7 Lee Miller file, Photography Collection, The Art Institute of Chicago, letter of 9 October 1976
8 'What they see in cinema', *Vogue* [London] (August 1956), p.46
9 Fitzgerald, quoted by Burke, pp.36–7
10 *Ibid.*, p.28
11 *Vogue*, [NY], 1 July 1928
12 Nancy Osgood, 'Accident was Road to Adventure, *St Petersburg Times*, 5 October 1969, quoted by Burke, p.40
13 Tag Gronberg, 'Paris 1925: Consuming Modernity', in Benton, C., Benton, T. and Wood, G. (eds), *Art Deco 1910–1939* (London, 2003), p.157
14 Burke, p.41
15 *Ibid.*, p.42
16 *Ibid.*, p.42
17 *Ibid.*, p.47
18 *Ibid.*, p.50
19 Penrose (1985), p.16
20 Quoted by Patricia Johnston, *Real Fantasies: Edward Steichen's Advertising Photography* (Berkeley, 1997), p.113
21 Penrose (1985), p.20
22 Amaya, p.59
23 Joseph Roth, *The White Cities: Reports from France 1925–39*, trans. Michael Hoffmann (London, 2004), p.31
24 Penrose (1985), p.22
25 Amaya, p.55
26 Brigid Keenan, *The Women We Wanted to Look Like* (New York, 1978), p.136
27 My thanks to Steven Manford for this information. Further details from his research on Man Ray's Rayographs are to be found in Sotheby's Photographs catalogue, 24 October 2002, in which the poster was lot 157.
28 *Arts & Decoration* (September 1929), p.108. Thanks to Steven Manford for this reference.
29 Keenan, p.136
30 Amaya, p.59
31 Burke, p.85
32 The identifications are not supported by, for example, Lawford (1985).
33 *Vogue* [Paris] (April 1930), p.34

34 Michael Gross, *Model* (London, 1995), pp.35–6
35 Boris Pasternak, *Dr Zhivago* (1958), pt 1, ch. 2, sect. 3
36 My view of the history of fashion photography is founded on Martin Harrison, *Shots of Style: Great Fashion Photographs Selected by David Bailey* (exhib. cat., Victoria and Albert Museum, London, 1986) and *Appearances: Fashion Photography since 1945* (London, 1991).
37 M. Haworth-Booth (ed.), *Personal Choice: A Celebration of Twentieth Century Photographs* (exhib. cat., Victoria and Albert Museum, London, 1983), pp.86–7
38 Amaya, p.56
39 *Ibid.*
40 V&A Research Department seminar, The Art of Lee Miller, 13 December 2005
41 MNAM, Man Ray Archive no. AM 1995-281(374). A later print from the whole negative, stamped MAN RAY/PARIS, is in the LMA.
42 *Vogue* [Paris] (April 1930), p.57
43 Penrose (1985), pp.30–32
44 Francis Steegmuller, *Cocteau: A Biography* (1970), pp.406–7
45 *Ibid.*, p.411
46 *Ibid.*, p.406
47 Cocteau, p.99
48 *Ibid.*, p.101
49 *Ibid.*
50 'What they see in cinema', *Vogue* [London] (August 1956), p.46

Chapter 2: Paris 1929–32

1 Jean Hubert Martin, *Man Ray: Photographs* 1982, pl.163, p.141. My thanks to Dr Walker for spotting the relationship between rug and Rayograph and for providing this reference.
2 Musée Nationale d'Art Moderne (Centre Georges Pompidou) nos 199.10, 199.14, 199.19, 199.27
3 Amaya, p.57
4 *Ibid.*, pp.55–7, 59–60
5 *Ibid.*, p.59
6 *Ibid.*, p.55
7 This photograph was sold at auction by Beaussant Lefèvre, Paris, on 30 November 1996, lot 26: its present whereabouts are unknown.
8 Arnold Crane papers, Archives of American Art, Man Ray interview, p.16. Information kindly provided by Steven Manford. With thanks to Arnold Crane.
9 Amaya, p.57
10 The mistake over the identity of the torso occurs in Roland Penrose, *Man Ray* (1975), p.99, and in the Amaya interview from the same year. The uncropped image of the torso, revealing the face of the actual model, appears in de l'Ecotais and Sayag, *Man Ray: Photography and Its Double* (London, 1998), p.149. However, the

misidentification with Lee continues to be made in otherwise authoritative works.
11 Both prints are in the LMA.
12 François Leperlier (ed.), *Claude Cahun: Photographe* (Paris, 1995), p.33
13 Whitney Chadwick, 'Lee Miller's Two Bodies', W. Chadwick and T.T. Latimer (eds), *The Modern Woman Revisited: Paris Between the Wars* (New Brunswick, NJ and London, 2003), p.215
14 *Ibid.*
15 *Ibid.*, p.214
16 *Ibid.*, p.215
17 Lee Miller file, Photography Collection, The Art Institute of Chicago, notes by LM on list of photos by her in the Julien Levy collection.
18 Carolyn Burke, *Becoming Modern: The Life of Mina Loy* (1996) describes and illustrates the late sculptures.
19 Personal communication from Sam Stourdze, who provided the text for Michael Comte (ed.), *Charlie Chaplin: A Photo Diary* (Gottingen, 2002).
20 Roth (2004), pp.200–1
21 *Ibid.*, p.74
22 Mary Ann Caws (ed.), *The Yale Anthology of Twentieth Century French Poetry* (New Haven, CT, 2005), pp.124–5, trans. Mary Ann Caws and Patricia Terry
23 Burke, p.98
24 A selection of these can be viewed at www.greenberggallery.com
25 Examples by Le Corbusier and Perriand are illustrated in Mary McLeod (ed.), *Charlotte Perriand: An Art of Living* (2003); a selection was shown at Paris-Photo in 2005 by Galerie Priska Pasquer, Cologne.
26 *Dada* (exhib. guide, Centre Georges Pompidou, Paris 2005), Room 4
27 Leah Dickerman *et al.*, *Dada* (Washington DC, 2005), p.292, pl.5.8
28 According to Antony Penrose, a print in the Lee Miller Archive once bore a typewritten label with the title *Impasse à Deux Anges*. Unfortunately, Lee's photograph bears no resemblance to the street of that name in the 6th *arrondissement*, so the photograph should perhaps be known for the time being, like others from the Paris period, as 'Untitled [*Street Scene*]'.
29 A print in the Art Institute of Chicago is also orientated, judging from the Lee Miller Studio stamp on the verso, in the same manner as the print in the Metropolitan Museum of Art.
30 Jennifer Mundy, Dawn Ades (eds), *Surrealism: Desire Unbound*, p.120
31 Lee Miller file, Photography Collection, The Art Institute of Chicago. A copy of the contact sheet is also in LMA.

32 Hal Foster, 'Violation and Veiling in Surrealist Photography: Woman as Fetish, as Shattered Object, as Phallus', Mundy (ed.), pp.203–6
33 Chadwick, p.215
34 Alain Sayag, *Eli Lotar* (Paris, 1994), pp.77–81. Lotar's abbatoir photographs were published in *Documents*, no.6 (1929); see Dawn Ades, *Undercover Surrealism* (London, 2006), p.112.
35 Chadwick, p.215

Chapter 3: New York 1932–34

1 Julia Blanshard, 'Other Faces Are Her Fortune', *Poughkeepsie Evening Star* (1 November 1932), quoted by Burke, p.128
2 Penrose (1985), p.44
3 Lee Miller file, Photography Collection, The Art Institute of Chicago, notes by LM
4 *Poughkeepsie Evening Star* (1 November 1932), quoted by Penrose (1985), p.54
5 Amaya, p.58
6 Lee Miller file, Photography Collection, The Art Institute of Chicago, LM letter to David Travis, 9 October 1976
7 *Vogue* (1 June 1934). The advertisement name-checked Bergdorf Goodman but did not credit Lee. However, a print in the collection of Margit Rowell bears Lee's studio stamp and is inscribed on the verso: 'An advertisement for a bridal shop in one of the big specialty stores – 1933'.
8 William Ewing, Agnès Sire *et al.*, *Documentary and Antigraphic: Photographs by Cartier-Bresson, Walker Evans and Alvarez Bravo* (Gottingen: Steidl, for Maison Européenne de la Photographie, Fondation Cartier-Bresson and Musée de l'Elysée, Lausanne, 2004)
9 *Ibid.*, p.28
10 Ingrid Schaffner and Lisa Jacobs (eds), *Julien Levy: Portrait of an Art Gallery* (MIT Press, 1998), p.163
11 KGS [Katherine Grant Sterne], 'European Photography on View', *New York Times* (25 February 1932), quoted by Burke, p.123
12 *Creative Art* (November 1932), p.222. The Campigli portrait was a solarization, reproduced in *Creative Art* (January 1933), p.76, present whereabouts unknown. A print of the Berman portrait is in the Philadelphia Museum of Art.
13 *Creative Art* (February 1932), p.128
14 The announcement is preserved in LMA.
15 E.A. Jewell, 'Two One-Man Shows', *New York Times* (31 January 1933); quoted by Burke, p.132
16 Burke, p.137
17 *Ibid.*, p.131
18 Penrose (1985), p.55
19 Burke, pp.137–8
20 Steven Watson, *Prepare for Saints* (New York, 1998), p.245; quoted by Burke, p.138

Bibliography

21 Watson, p. 6; quoted by Burke, p.139
22 Christie's, New York, Photographs sale, 18 October 1990. Lot 352 was *Caged Birds*, a variant of our Pl. 44, signed and dated, stamped on the reverse by the photographer and the Levy Gallery; this print is now in the Jill Quasha Collection, New York. Lot 353 was *Condom*. The provenance of both lots was given as Julien Levy Gallery. Christie's hold no record of the identity of the consignor.

Chapter 4: Egypt, 1934–37
1 E.M. Forster, 'Alexandrian Vignettes: Photographic Egypt', *The Uncollected Egyptian Essays*, ed. Hilda D. Spear and Abdel-Moneim Aly (London, 1988), p. 52
2 *Ibid.*, p. 53
3 Burke, p.151
4 Arthur Gold and Robert Fizdale, 'The Most Unusual Recipes You Have Ever Seen', *Vogue* [NY] (April 1974), p.186, quoted by Burke, p.149
5 Quoted by Burke, p.160
6 Penrose (1985), p. 65
7 *Ibid.*, p.60
8 *Ibid.*, p.78
9 Burke, p.181
10 *Ibid.*, p.161
11 *Ibid.*, p.183
12 Robin Fedden, *Syria: A Historical Appreciation* (London, 1946, rev. ed. 1955) and *Syria and Lebanon* (London, 1965)
13 'Sur les Toits de Paris: le jardin enchanté de M. Charles de Beistegui', *Vogue* [Paris] (September 1932), pp. 54–5
14 Robin Fedden, *Egypt* (1977), p.128
15 Lee's description is published in David Sylvester and Sarah Whitfield, *Oil Paintings and Objects*, vol. II of *René Magritte: Catalogue* Raisonné, ed. David Sylvester (1993), p. 265
16 Penrose (1985), p. 90
17 Burke, p.164
18 *Ibid.*, p.165
19 Penrose (1985), p. 78
20 This and other works from the trip have now been published by Falmouth Art Gallery, with an essay by Antony Penrose, as *The Surrealists in Cornwall* (2004).
21 *London Bulletin*, nos 18–20 (June 1940), p.15
22 Sylvester and Whitfield, pp. 264–5
23 Roland Penrose to Lee Miller, 22 October 1937, quoted by Burke, p.179
24 Lee Miller to Roland Penrose, 9 November 1937, quoted by Burke, pp. 179–80
25 Burke, p.180
26 This was reissued by the Arts Council of Great Britain in 1980 and by Getty Publications in 2003.
27 Burke, pp.189–91

Chapter 5: War
1 *Vogue* [London] (January 1940), p.11
2 Burke, pp.115–16 describes these visits, on which Lee was mainly involved with stills on the set of the film *Stamboul*. Lee appeared as both photographer and model in British *Vogue* on 10 June 1931.
3 Penrose (1985), p. 98
4 *Ibid.*
5 Mark Haworth-Booth, *Things: A Spectrum of Photography* (London, 2004), pp.178–9
6 *Vogue* [London] (March 1940), p. 63
7 *Vogue* [London] (September 1941 and April 1941)
8 Alex Kroll, private communication
9 Karen A. Levine, 'Model Photographer: Collaboration and Performance in the Work of Lee Miller' (MA thesis submitted to the Faculty of Arts, San Francisco State University, 2000), p. 43
10 Penrose (1985), p.112
11 *Ibid.*, p.114
12 *Ibid.*
13 Alex Kroll, private communication
14 Penrose (1985), p.120
15 Burke, p. 265
16 Hannah Arendt, *Eichmann in Jerusalem: A Report on the Banality of Evil* (New York, 1963)
17 Penrose (1992), p.176
18 Menzel-Ahr, pp.144–9
19 Quoted by Caroline Seebohm, *The Man Who Was Vogue: The Life and Times of Condé Nast* (New York, 1982), p.354

Chapter 6: Post-war
1 Antony Penrose, private communication
2 The role of the Combined Societies in post-war British photography is discussed in M. Haworth-Booth, *The Street Photographs of Roger Mayne* (London, 1986), pp.67–8
3 Becky E. Conekin, 'Lee Miller and the Limits of Post-war British Modernity: Femininity, Fashion, and the Problem of Biography', Christopher Breward and Caroline Evans (eds), *Fashion and Modernity* (2005)
4 Lee Miller file, *Vogue* Archives, Vogue House, London

Amaya, Mario, 'My Man Ray: An Interview with Lee Miller Penrose', *Art in America* (New York, May–June 1976), vol. 63, no. 3, pp. 54–61

Blessing, Jennifer, *et al.*, *Speaking with Hands: Photographs from The Buhl Collection* (New York, 2005)

Burke, Carolyn, *Lee Miller: A Life* (London, 2005)

Carter, Ernestine (ed.), preface by E.R. Murrow, *Grim Glory: Photographs by Lee Miller and Others* (London, 1940), reissued as *Bloody but Unbowed: Pictures of Britain under Fire* (New York, 1941)

Calvocoressi, Richard, *Lee Miller: portraits from a life* (London, 2002)

Calvocoressi, Richard and Hare, David, *Lee Miller Portraits* (National Portrait Gallery, exhib. cat., London, 2005)

Cocteau, Jean, *Le Sang d'un poète* (essay by Cocteau on his film of the same title, plus stills) (Paris, 1948)

Davis, Melody, 'Lee Miller: Bathing with the Enemy', *History of Photography* (London, Winter 1997), vol. 21, no. 4, pp. 314–18

Hubert, Renée Riese, 'The Model and the Artist: Lee Miller and Man Ray', *Magnifying Mirrors: Women, Surrealism, and Partnership* (Lincoln; London, 1994)

Lawford, Valentine, *Horst: His Work and His World* (Harmondsworth, 1985)

Livingston, Jane, *Lee Miller, Photographer* (London, 1989)

Lloyd, Valerie, 'Lee Miller', *Creative Camera* (London, December 1982), 216, pp. 760–65

Lyford, Amy J., 'Lee Miller's Photographic Impersonations, 1930–1945: Conversing with Surrealism', *History of Photography* (London, Autumn 1994), vol.18, no. 3, pp. 230–41

Mellor, David Alan, 'Lee Miller: The Shocks of Liberation', in *Wherever I Am: Yael Bartana, Emily Jacir, Lee Miller* (Museum of Modern Art Oxford, exhib. cat., Oxford, 2004)

Menzel-Ahr, Katharina, *Lee Miller, Kriegskorrespondentin für Vogue: Fotografien aus Deutschland 1945* (Marburg, 2005)

Miller, Lee, 'I Worked with Man Ray', *Lilliput* (London, October 1941), vol. 9, no. 4, pp. 315–24

Mundy, Jennifer and Ades, Dawn (eds), *Surrealism: Desire Unbound* (London, 2001)

Penrose, Antony, *The Lives of Lee Miller* (New York, 1985)

Penrose, Antony, *Lee Miller's War: Photographer and Correspondent with the Allies in Europe, 1944–45* (London, 1992)

Penrose, Antony, *et al.*, *The Surrealist and the Photographer: Roland Penrose and Lee Miller*, (Scottish National Gallery of Modern Art, exhib. cat., Edinburgh, 2001)

Ray, Man, *Self-portrait* (London, 1963)

Surrealist Muse: Lee Miller, Roland Penrose, and Man Ray (The J. Paul Getty Museum, exhib. cat., Los Angeles, 2003)

Travis, David, *Photographs from the Julien Levy Collection, Starting with Atget* (Chicago, 1976)

Ware, K., and Barberie, P., *Dreaming in Black and White: Photography at the Julien Levy Gallery* (Philadelphia, 2006)

72
Untitled [Severed Breast from Radical Mastectomy], *c.*1930.
Two photographs: left: 8.5 × 5.5. right: 7.6 × 5.5. LMA

73
Self-portrait in Headband, published 1933.
15.6 × 16.1. LMA

74
Solarized Portrait of Lilian Harvey, 1933.
18.9 × 23.1. LMA

75
Solarized Portrait of Dorothy Hill, 1933.
24.9 × 19.2. LMA

76
Solarized Portrait of Dorothy Hill (Profile), 1933.
24.0 × 19.0. LMA

77
Floating Head (Mary Taylor), 1933.
19.0 × 24.1. LMA

78
Solarized Piano, 1933.
Inscribed. 24.2 × 19.1.
Marnie and Victor Ceporius Collection, Los Angeles

79
Mary Chess Cosmetics, 1933.
Inscribed. 18.5 × 23.8. LMA

80
Scent Bottles, 1933.
18.8 × 23.9. LMA

81
John Rodell, *c.*1933.
18.9 × 13.8 (irregular). LMA

82
Mr and Mrs Donald Friede, *c.*1933.
Inscribed in ink. 8.0 × 6.0. LMA

83
Gene Tunney, 1932.
Inscribed and titled. NY stamp, Levy stamp 2. 32.8 × 26.9.
PMA, museum no. 2001-62-809.
Philadelphia Museum of Art:
The Lynne and Harold Honickman Gift of the Julien Levy Collection, 2001.
Photo by Andrea Simon

84
Joseph Cornell, 1933.
16.4 × 20.5. LMA

85
Object by Joseph Cornell, 1933.
20.9 × 16. LMA

86
Joseph Cornell, Untitled, *c.*1949 (collage of Lee Miller).
21.9 × 26.4. Vivian Horan Fine Art, New York. © The Joseph and Robert Cornell Memorial Foundation

87
Gertrude Lawrence, 1933.
24.1 × 19.1. LMA

88
Untitled [Woman with Furs], 1933.
20.6 × 16.2. LMA

89
Miss Lee Miller (Coiffure by Dimitry), *Vogue* (New York), 1 March 1933.
15.8 × 20.5. LMA

90
Cosmetics in Colour, proof of Tri-Carbro colour photograph, 1933–4.
21.0 × 16.0 (irregular). LMA

91
Virgil Thompson, 1933.
20.5 × 15.8. LMA

92
John Houseman, 1933.
20.7 × 15.7. Modern print by Carole Callow. LMA

93
Frederick Ashton, 1933.
24.1 × 19.0. Frances Lehman Loeb Art Center, Vassar College, museum no. 1996.27.1.
© Lee Miller Archives, England 2007. All Rights Reserved

94
Bertha Fitzhugh Baker, St Settlement in Four Saints in Three Acts, 1933.
Image: 25.0 × 18.8. Cropped to 12.5 × 9.5 (irregular). LMA

95
Eva Jessye, Choir Mistress, Four Saints in Three Acts, 1933.
Inscribed on reverse in pencil: *Jessye*. 20.5 × 15.8. LMA

96
Condom, *c.*1934?
22.8 × 17.2. Buhl Collection, 212.274.0100

97
From the Top of the Great Pyramid, *c.*1937.
5.8 × 5.3. LMA

98
Unknown photographer, *Lee Miller with Rolleiflex*, Egypt, 1935.
13.6 × 9.0. LMA

99
Untitled [Restaurant Table] Egypt, *c.*1935–9.
5.7 × 5.5. LMA

100
Untitled [Dunes] Egypt, *c.*1935–9.
5.4 × 5.4. LMA

101
Untitled [Cement Factory], Egypt, *c.*1935–9.
5.6 × 5.3. LMA

102
Untitled [Sacks], Egypt, *c.*1935–9.
5.7 × 5.4. LMA

103
Untitled [Monastery Architecture], Egypt, *c.*1935–9.
5.8 × 5.3. LMA

104
Untitled [Erosion Bird Rock], Egypt, *c.*1935–9.
5.6 × 5.3. LMA

105
Untitled [Monastery: Being Welcomed with Drinks], Egypt, *c.*1935–9.
5.5 × 5.4. LMA

106
Untitled [Pigeon Guano Farm, Egypt], *c.*1935–9.
5.6 × 5.4. LMA

107
Untitled [The Black Satin and Pearls Set], Cairo, 1935–9.
5.7 × 5.2. LMA

108
The Cloud Factory, Assyut, 1939.
13.4 × 12.2. LMA

109
Untitled [Snail Shells], *c.*1936.
Signed in black ink on the print.
27.9 × 25.6. LMA

110
Untitled [Stairway], *c.*1936.
Signed in black ink on the print.
27.9 × 25.4. LMA

111
Castle Ruins, *c.*1936.
22.8 × 22.8. LMA

112
The Monasteries of Deir Simon and Deir Barnabas, Sinai Peninsula, *c.*1936.
12.4 × 12.3. LMA

113
Domed roofs, Wadi Natrun, *c.*1936.
13.3 × 12.7. LMA

114
Monastery of Wadi Natrun: Doorway, *c.*1936.
12.7 × 12.7. LMA

115
Restoration of Roman Ruins, El Kharga, *c.*1936.
13.5 × 12.8. LMA

116
The Native, also known as Cock Rock, Western Desert, 1939.
13.4 × 13.0. LMA

117
Roland Penrose, Egypt, 1939.
20.0 × 12.0. Modern print by Carole Callow. LMA

118
Portrait of Space, variant 1, 1937.
5.7 × 5.5. LMA

119
Portrait of Space, variant 2, 1937.
5.7 × 5.5. LMA

120
Portrait of Space, variant 3, 1937.
5.4 × 5.3. LMA

121
Portrait of Space, variant 4, 1937.
5.4 × 5.3. LMA

122
Portrait of Space, final version, 1937.
13.3 × 12.4. LMA

123
The Procession, Red Sea, 1937.
5.7 × 5.2. LMA

124
Eileen Agar at the Royal Pavilion, Brighton, 1937.
Modern print by Carole Callow.
26.0 × 25.0. LMA

125
René Magritte, *Le Baiser*, 1938.
Oil painting. 18.0 × 24.0. Musées Royaux des Beaux-Arts de Belgique, Brussels – Koninklijke Musea voor Schone Kunsten van België, Brussels

126
Picnic: Nusch and Paul Eluard, Roland Penrose, Man Ray, and Ady Fidelin, Île Sainte-Marguerite, Cannes, France, 1937.
5.7 × 4.3. LMA

127
Dora Maar, Mougins, 1937.
21.0 × 30.0. Modern print by Carole Callow. LMA

128
Unknown photographer, *Roland Penrose and Lee Miller, sculptures shown in 'Surrealist Objects & Poems'*, London Gallery, 1937.
Sculpture by LM at lower left (arm with dental bracelet).
20.4 × 14.8. LMA

129
Shoes made from Old Car Tyres, Romania, 1938.
13.0 × 12.1. LMA

130
On The Road, Romania, 1938.
Signed in black ink on the print.
27.8 × 25.7. LMA

131
Cemetery Tree Crosses, Romania, 1938.
13.0 × 12.1. LMA

132
Women with Fire Masks, Downshire Hill, London, 1941.
Modern print by Carole Callow.
26.0 × 25.0. LMA

133
Military Alliance, *Vogue*
(London), March 1940.
Vogue magazine single page.
LMA. Photographed by Lee
Miller for British *Vogue*

134
Remington Silent, London 1940.
19.5 × 18.6. LMA

135
University College, London 1940.
25.6 × 24.2. LMA

136
Revenge on Culture, London,
1940.
25.6 × 24.2. LMA

137
Indecent Exposure, 'Please take
me away...', London, 1940.
17.9 × 17.8. LMA

138
War and Peace in a London Park,
London, 1940.
17.9 × 17.8. LMA

139
'Good and Bad Posture', *Vogue*,
London, February 1942.
33.1 × 24.3 (sheet: 50.8 × 35.6).
LMA. Photographed by Lee
Miller for British *Vogue*

140
'Night Life Now': ATS Searchlight
Crew, *Vogue*, London, June 1943.
Modern print by Carole Callow.
26.0 × 25.0. LMA. Photographed
by Lee Miller for British *Vogue*

141
'Night Life Now': ATS Searchlight
Crew, *Vogue*, London, June 1943.
30.7 × 45.9. *Vogue* magazine
double page spread. LMA.
Photographed by Lee Miller for
British *Vogue*

142
Life *Photographer David E.
Scherman Equipped for War*,
1942.
25.3 × 20.4. LMA

143
David E. Scherman, *Lee Miller in
Uniform*, London, 1944.
25.5 × 20.2. LMA

144
'Cover Coats', *Vogue*,
January 1943.
30.0 × 23.0 (irregular). NAL.
Photographed by Lee Miller for
British *Vogue*

145
Humphrey Jennings, London,
1944.
20.4 × 25.4. National Portrait
Gallery. © Lee Miller Archives,
England 2007. All Rights
Reserved

146
*'Citizens of the World –
Ed Murrow'*, *Vogue*, London,
August 1944.
26.0 × 25.0. LMA

147
'Unarmed Warriors', *Vogue*,
London, September 1944.
28.6 × 22.0 *Vogue* single page.
30.7 × 24.6 (irregular) *Vogue* tear
sheet separate page. LMA.
Photographed by Lee Miller for
British *Vogue*

148
'Unarmed Warriors', *Vogue*,
London, September 1944.
28.6 × 22.0 *Vogue* single page,
30.8 × 23.4 (irregular) *Vogue* tear
sheet separate page. LMA.
Photographed by Lee Miller for
British *Vogue*

149
Surgeon and Anaesthetist,
La Cambe, 1944.
14.7 × 15.1. LMA

150
*Loading Wounded into
Evacuation Aircraft*,
La Cambe, 1944.
16.0 × 15.7. LMA

151
*Lee Miller and Pablo Picasso,
Liberation of Paris*, 1944.
23.0 × 20.1. LMA

152
Liberation of Paris, *Vogue*,
October 1944.
29.1 × 44.8. *Vogue* magazine
double page spread. LMA.
Photographed by Lee Miller for
British *Vogue*

153
St Malo, *Vogue*, London,
October 1944.
29.1 × 22.4. *Vogue* magazine
single page. LMA. Photographed
by Lee Miller for British *Vogue*

154
*Bombs Bursting on the Cité
d'Aleth*, St Malo, 1944.
SHAEF censorship stamp on
reverse plus typewritten caption.
12.9 × 12.8. LMA

155
*Bruyère's Quilted Windbreaker
outside the Bruyère Salon*, *Place
Vendôme*, Paris, 1944.
Modern print by Carole Callow.
26.0 × 25.0. LMA

156
*Queuing up to See the Paris
Collections* (detail), Paris, 1944.
Modern print by Carole Callow.
26.0 × 25.0. LMA

157
Loire Bridges, *Vogue*, London,
November 1944.
28.6 × 43.6. LMA. Photographed
by Lee Miller for British *Vogue*

158
*Players in Paris (Marlene Dietrich
and Fred Astaire)*, *Vogue*,
London, December 1944.
29.2 × 44.8. LMA. Photographed
by Lee Miller for British *Vogue*

159
Paris Under Snow, *Vogue*, March,
January 1945.
29.1 × 44.8. *Vogue* magazine
double page spread. LMA.
Photographed by Lee Miller for
British *Vogue*

160
Scales of Justice, *Vogue*, London,
June 1945. 29.1 × 22.4. *Vogue*
magazine single page. LMA.
Photographed by Lee Miller for
British *Vogue*

161
*Chemical Works Wrecked by
Allied Bombers*, Ludwigshaven,
Germany 1945.
15.7 × 15.0. SHAEF censor stamp,
dated 10 APR 1945, and typed
caption. LMA

162
'Germans Are Like This', *Vogue*,
New York, June 1945.
31.2 × 47.0. *Vogue* magazine
double page spread. LMA.
Lee Miller/*Vogue*. © (1945) Condé
Nast Publications. Reprinted by
permission. All Rights Reserved

163
'Believe It', *Vogue*, New York,
June 1945.
31.2 × 47.0. *Vogue* magazine
double page spread. LMA.
Lee Miller/*Vogue*. © (1945) Condé
Nast Publications. Reprinted by
permission. All Rights Reserved

164
*Bürgermeister of Leipzig's
Daughter Suicided*, Leipzig,
Germany, 1945.
15.9 × 15.1. SHAEF censor stamp
dated 30 APR 1945, and typed
caption. LMA

165
Dead SS Guard in Canal,
Dachau, Germany, 1945.
15.8 × 15.2. LMA

166
'Hitleriana', *Vogue*, London,
July 1945.
29.2 × 44.4. *Vogue* magazine
double page spread. LMA.
Photographed by Lee Miller for
British *Vogue*

167
*Interior of Hitler's apartment on
Prinzregentenplatz, showing King
George VI Mug*, Munich, 1945.
16.1 × 15.3. LMA

168
Sgt Arthur Peters Reading Mein
Kampf *and Using the 'Hotline' in
Hitler's Apartment*, Munich, 1945.
16.0 × 15.3. LMA

169
David E. Scherman, *Lee Miller in
Hitler's Bath*, Munich, 1945.
16.0 × 15.1. LMA

170
View from Farley Farm, 1952.
Modern print by Carole Callow.
26.0 × 25.0. LMA

171
Drawing by Vic Volk, *Lee Miller
on* Vogue's *Roundabout*, Vogue
London, August 1946.
30.0 × 22.5. Tear sheet single
page. LMA.

172
*Antony Penrose and
Mrs De Valera*, Hampstead, 1948.
8.8 × 8.4. LMA

173
Hampstead Fair, London, 1949.
42.1 × 39.0. LMA

174
Hampstead Station, 1949.
Inscribed. 42.1 × 39.0. LMA

175
Picasso and Antony Penrose,
Sussex, 1950.
25.8 × 19.3. LMA

176
*'Working Guests': Dorothea
Tanning and Max Ernst*, Farley
Farm, 1950.
Modern print by Carole Callow.
26.0 × 25.0. LMA

177
*'Working Guests': Alfred H. Barr
Jr. Feeding the Pigs*, Farley Farm,
1952.
Modern print by Carole Callow.
26.0 × 25.0. LMA

178
*'Working Guests': Richard and
Terri Hamilton*, Farley Farm,
c.1951.
19.9 × 18.9. LMA

179
*'Working guests': Saul Steinberg
at Farley Farm*, 1953.
Modern print by Carole Callow.
26.0 × 25.0. LMA

180
*'Working guests: The Hostess
Takes it Easy'*, Farley Farm, 1953.
Modern print by Carole Callow.
20.0 × 26.0. LMA

What they see in cinema (Vogue, August 1956)

The first theatrical performance I ever attended was in the Poughkeepsie Opera House. It seems highly unlikely, but is memorable and true that the 'Bill' consisted of Sarah Bernhardt in person, playing the 'greatest passages from her greatest rôles', from a chaise-lounge; secondly, artistic, immobile nudes, imitating Greek sculpture (livid, in quivering limelight); and as a curtain-raiser there was a guaranteed, authentic 'Motion Picture'. The Divine Sarah dying on a divan was of considerable morbid interest to me as a seven year old. Though I understood no French, her Portia, pleading, seemed urgent enough (she was propped up vertical for that); the nudes were just more ART. But the 'Motion Picture' was a thrill-packed reel of a spark-shedding locomotive dashing through tunnels and over trestles. The hero was the intrepid cameraman himself who wore his cap backwards, and was paid 'danger-money'. On a curve across a chasm, the head of the train glared at its own tail ... the speed was dizzy, nothing whatever stayed still and I pulled eight dollars worth of fringe from the rail of our loge, in my whooping, joyful frenzy.

No wonder the repertory companies disbanded and the Opera Houses installed screens. They had heroic fare to offer. Dishevelled girls staggered from the private quarters of the Crown Prince of Germany who raped his way across Belgium while his officers tortured civilians behind haystacks. The Kaiser himself was busy gloating over the Zeppelin raids, the chopped-off hands of little children and the 'worse-than-death' fate of nuns and nurses. Oh! how gloaty was the gloating, how lecherous the leer and oh, how pure the innocent. Kultur! was the cry, as another library was bombed to dust. There were all kinds of spies, and a captain of the British Navy, driven mad by the atrocities he had witnessed, captured the slavering submarine commander, trussed him up in the shower bath and skinned him alive.

We had Mae Murray and her 'bee-stung' lips, Allan Dwan devised a 'test for Pulchritude', we knew what the bride really said at the altar, by lip reading ... all this and Epics, too. The Opera stars came back to the Opera House, but silently, on the silver-screen: Lina Cavallieri thumbed-down handsome gladiators and orgied through ancient history; Geraldine Farrar in shining armour besieged Orleans as Joan of Arc, with noble Wallace Reid by her side. As grand as a Delacroix was the scene.

I'm not moaning for the good old days. Old films aren't even good for laughs. The youngsters who see them at Film Society shows are straight-faced serious about ART in the Cinema while we shed tears of confusion and embarrassment, not of nostalgia. My mind's eye and my memory enfold and enrich glamorous versions of *The Last Days of Pompeii*, *The Ten Commandments* and *The Crusades*. Leave them in their cans because every season brings a new crop ... bigger and better, of exactly the kind of film I adore: the great big epic! Just like the great, big nineteenth-century paintings – bold and dramatic and B.I.G.

I love extravagant and gorgeous "historicals" – melodrama, ambiguity, inaccuracy and all, as long as the heroes are close-up close and the background has panoramic splendour. I love the strident nonsense of the big muscles. I love ballets which have quit the stage. I love boy-meets-girl skirmishes and the improbable dialogue of the bright comedies.

Visual literature offers us variety in vicarious living. At roughly 1s. 9d. an hour we explore the underwater worlds of Esther Williams; Captain Nemo and Cousteau. We invade the skies as Everest climbers, bomber heroes and space-men and from a position of security and comfort we can watch a bud

unfold, the private life of the lion or the eagle, and even leeches feeding on Miss K. Hepburn's thighs. Mind, body and soul are probed and presented to extend our experience: the snake-pit, the bedroom and the cloister are wired for sound and vision. We can hold the hand of Picasso as he draws or preview our own destruction in a mushroom-shaped cloud. Take your choice, full colour, or black and white.

Cliff-hangers, tear-jerkers; martyrs, chorus girls, heroes and crooks: gaudy, always, and often corny, idiotic or ham. I love them all from *Reap the Wild Wind* to the new Soviet *Othello*. What a parade of sword swishers, Delilahs, Helens, Caesars and Saints; it's pretty good going to be awed, educated and entertained simultaneously.

In fact, my love is greedy. Since I haven't the three thousand years forced on the Wandering Jew I won't be able to spend a few life-times on the trapeze, bird-watching or exploring the Amazon, or decades or even centuries to satisfy all the other curiosities and absurdities which assail me, but I can sample them in films. There is a flash of poetry in every motion picture; often it is born of motion alone. It might be the way an arm moves, a shadow falls, or some dust settles. It can be a faint spark in a million pound job scripted by Shakespeare, or like a flame in a trashy B-film.

This poetic quality is a special thing, usually unforeseen, although directors and cameramen chase it from the Jungle to the Atom Pile. They realize that *King Kong* was packed with it, that Garbo is endowed with it, and that neither study, sincerity, taste nor trying can synthesize or pin it down. The truth is that only a poet can make a poem.

Jean Cocteau called his first film 'a poem on celluloid' and entitled it *The Blood of a Poet*. It was a masterpiece. It has become a classic and now, twenty-five years later, the boys are still finding ideas to lift from it.

If poems and pictures and masterpieces are traditionally made in sordid surroundings such as garrets and jails; if chaos and misunderstanding is the poet's lot, this film was blessed ... all augured well. The studio had been emergency sound-proofed: lined with all of the available second-hand mattresses in Paris. They, in turn, were stuffed with the kind of insect life typical of mattresses; we were devoured, itchy and stoical. The magnificent crystal chandelier for the card-game scene in the courtyard arrived in the nick of time, but in three thousand, numbered pieces, each wrapped separately in acid-free tissue paper.

The great bull came, but he had only one horn and no *bouvier* (that's the man who says code words to oxen, like fee, fye, fo, fum so that they stop and start and steer from side to side).

The butter-flour mixture which joined sculptured papier-mâché hair to my forehead melted, rancidly, and stained the plaster of my broken arms while my real arms throbbed and turned blue in their bindings (I was the statue in this affair).

The church threw fits, the "patrons" were persecuted and the finished picture languished in a vault for a couple of years.

None of the mishaps and accidents of production found Cocteau without an improvisation which was to his advantage. He himself, elegant, shrill, and dedicated, knew exactly what he wanted and got it. He screamed and cajoled. He electrified everyone who had anything to do with the film, from sweepers to tax-collectors. In a state of grace we participated in the making of a poem.

Acknowledgements

Before I retired from the V&A in 2004, Antony Penrose invited me to curate the centenary show of his mother's work. Of course, I accepted at once. It has been a great pleasure to work with Antony, who has given me not only his complete support but also – surely not easy for the world expert on Lee Miller – a completely free hand in making my choices. We made two research trips together to the US in 2005, visiting public and private collections. We received the most generous help from curators and collectors. On behalf of Antony, myself and the V&A, I should like to record our deepest gratitude here: to David Travis, curator of photography at the Art Institute of Chicago, who opened his invaluable Lee Miller files to us with great kindness, and his colleagues Kate Bussard and Lisa D'Acquisto, and also to Peter Blank, librarian of the Art Institute; to Marianne Courville, curator, and Ryan Ross at the Henry Buhl Collection, New York; to Marnie and Victor Ceporius, Los Angeles, not only for access to family papers and photographs but also for their very kind hospitality; to Vivien Horan and staff at Vivien Horan Fine Art, New York; to Roz Jacobs, New York; to Malcolm Daniel, curator in charge, Department of Photographs, The Metropolitan Museum of Art, New York; to John and Patricia Miller, Poughkeepsie; to Joel Smith, then curator at the Frances Loeb Art Center, Vassar College, Poughkeepsie; to Peter Galassi, chief curator, Department of Photography, The Museum of Modern Art, New York, and Simon Bieling, Beaumont Newhall Fellow; to Daniel Newburg, director of artandphotographs ltd, London; to Steven Maklansky, assistant director for art and curator of photographs at the New Orleans Museum of Art; to Kate Ware, curator of photographs, and Peter Barberie, Horace W. Goldsmith Curatorial Fellow, the Philadelphia Museum of Art; to Marilyn Pearl Loesberg, Palm Springs; to Jill Quasha, New York; to Paul Sack, San Francisco; to Sandra Phillips, senior curator of photographs, and Erin Garcia, curatorial associate, San Francisco Museum of Modern Art.

We also made a research trip to Paris in 2005 and are most grateful to Margit Rowell, not only for granting access to her private collection but also for joining us on our visit to the Man Ray Archive at the Centre Georges Pompidou. For their most gracious support of our research, especially as major building works were being undertaken at the time, we thank Alain Sayag, Quentin Bajac and Annyck Graton, curators in the Photography Collections at the Centre Georges Pompidou.

In addition to those already mentioned in the Introduction, many other friends and colleagues provided invaluable help during the course of the research for the book and exhibition: Dr David Bate, University of Westminster, London; Jonathan Bayer, London; Galerie Berinson, Berlin; Whitney Chadwick, San Francisco; Ann Colcord, London; Noma Copley, New York; Marie Difilippantonio, curator of the Julien Levy Archive, Newtown, Connecticut; Philippe Garner, London; Martin Harrison, Northampton; Howard Greenberg, New York; G. Ray Hawkins, Los Angeles; Edwynn Houk, New York; David Knaus, Palm Springs; Alex Kroll, London; Ulrich Lehmann, V&A Research Department; Bettina McNulty, London; Steven Manford, New York; Marion Meyer, Paris; Robin Muir, London; Dr Jennifer Mundy, Tate, London; Sam Stourdze, Paris; the Royal Opera House Collections, London; Tessa Traeger and Patrick Kinmonth, London; Ann Tucker, senior curator of photographs, and Del Zogg, Works on Paper Study Center, Museum of Fine Arts, Houston; the staff of Vogue Archives, London; Diane Waggoner, assistant curator, National Gallery of Art, Washington, DC; Dr Ian Walker, Newport School of Art, Media and Design, University of Wales, Newport; Thomas Walther, New York; Nigel Warburton, Oxford; Michael and Jane Wilson, Violet Hamilton and Polly Fleury, the Wilson Centre for Photography, London; Yuka Yamaji, Christie's, London; and Judith Young Mallin, New York.

Warmest thanks are due to the staff of the Lee Miller Archives at Muddles Green, Chiddingly, East Sussex – not only, once more, to Antony Penrose, its director, but also to Carole Callow, curator and photographic fine printer, Ami Bouhassane, archivist, Arabella Hayes, registrar/picture librarian, and Hannah Matthew, then digital librarian, and Lance Downie, digital librarian.

It was marvellous to work again, so soon after my retirement, with my colleagues at the V&A: in the Exhibitions team, Linda Lloyd Jones, Poppy Hollman, Ann Hayhoe and Charlotte King; in V&A Publications, Mary Butler, who commissioned me to write this book, my editor Ariane Bankes – before her departure to a new career – Clare Davis on production and Asha Savjani for her support on both text and illustrations. Special thanks are also due to Geoffrey Winston for his distinguished and sympathetic book design.

London, July 2006

Index

Page numbers in *italics* refer to illustrations